HOLY COW!

EVENING STANDARD READERS
CHOOSE THEIR FAVOURITE COLUMNS
BY CHARLES SAATCHI

Published by

PALAZZO

HOLY COW!

CHARLES SAATCHI
IN THE EVENING STANDARD

Contents

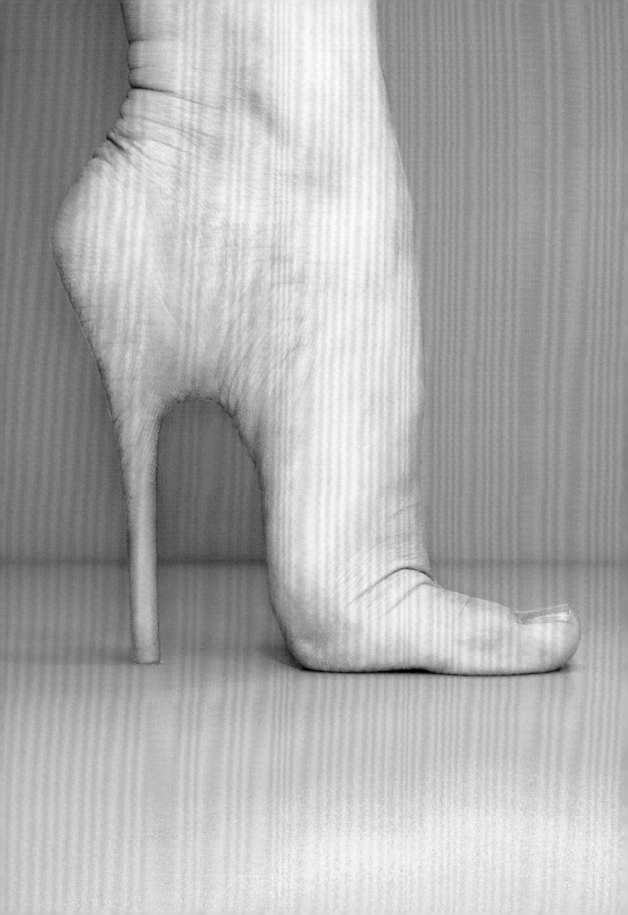

The next step in evolution.

Humans are continually transforming, with changes occurring at the blink of an eye in evolutionary terms.

For example, we have become much taller as a species, spurting in height by an average of 10cm – just in the years since the beginning of the 20th century.

Better nutrition and fuller bellies have helped most children across the world grow larger – the more nourishment we get, the more energy we produce to create growth hormones.

Over the next 200,000 years it is estimated that we could easily double in height, with some predictions having us reaching treetop loftiness.

However, we will also become more feeble – very tall, but with muscles that have atrophied through lack of use.

The human race will simply weaken as future technology takes the strain, machines doing virtually all manual work.

As each generation becomes less dependent on physical strength, our species as a whole will emerge less muscular.

And it won't be just our muscles that will be missed in the future. Having lost the majority of body hair over the millennia, it is likely that humans will become increasingly bald as a species.

If losing our muscles and hair isn't enough, it is also anticipated that we will have smaller, and fewer, teeth.

Our wisdom teeth, which serve no use to modern humans, will disappear over time, with evidence showing that in the last 10,000 years, our teeth have halved in size.

Also, before humans began to walk upright, our very large toes were used for grappling – much like our hands.

With our feet now sadly incapable of grasping even little branches, evolution will take steps to rid us of our smallest toes.

Whereas our other toes are an aid to balance and walking, our little toes serve no real purpose, and humans can get by perfectly well without them.

Because of this, and taking into account other problems which arise from

their needless existence – being frequently crushed in shoes, or stubbed on something – we can expect to eventually evolve into four-toed creatures.

A key prediction for future man is of a monocultural society.

Humans are expected to meld into a single, ubiquitous ethnic group, as the mixing of cultures continues.

Humans will slowly begin to lose the distinguishing features of present day geography, and instead take on characteristics from many different parts of the world.

When Steven Jones, a genetics professor at University College London, put forward a scenario that the human population will become more alike as races merge, he stated his belief that "Darwin's machine has lost its power."

He is convinced that the Darwinian "survival of the fittest" concept is being side-lined in humans.

The fittest will no longer spearhead evolutionary change.

Thanks to medical advances, the weakest also live on and pass down their genes.

When *On the Origin of Species* was published in 1859, only about half of British children survived to 21.

Today that number has swelled to 99 per cent.

Instead of living fast and dying young, it appears that humans will live much slower and die much older.

And what if Christian Louboutin and Jimmy Choo style six-inch stilettos remain a fixture on female feet for another few centuries?

Perhaps the picture here will prove not so far-fetched.

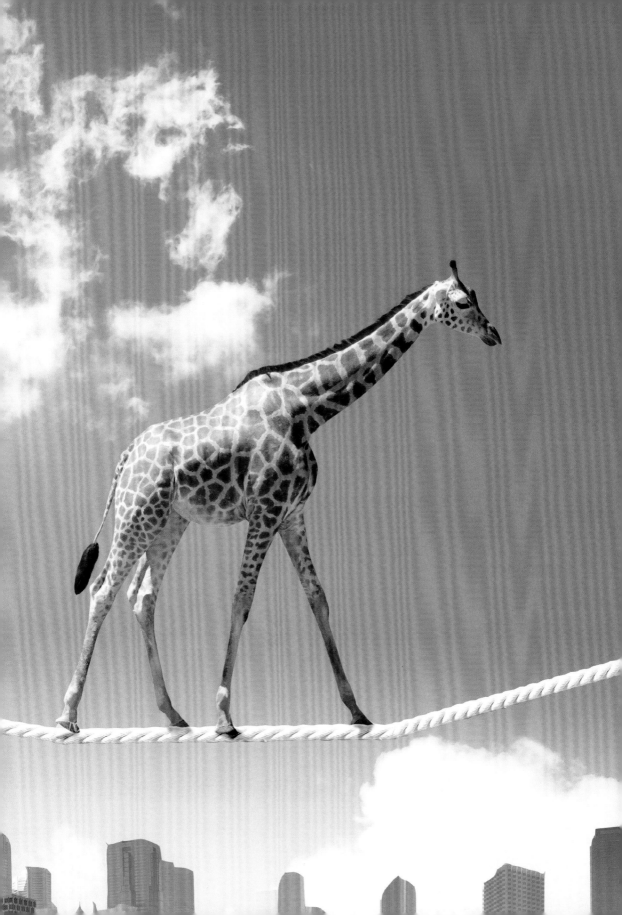

Do you dream of giraffes?

According to the *Dream Dictionary*, having a giraffe appear in your dreams suggests that you should try to see the overall picture in any matter troubling you. Possibly, it may also be a metaphor to warn you not to stick your neck out in a troubling situation.

In the dream guide, listed just above giraffe you will find ginseng, and should some of it materialise in your sleeping state, it represents vitality and longevity.

If like me you have no idea what ginseng looks like, simply consider yourself fortunate if this herbal plant with fleshy roots pops into your dreams – you can look forward to a lengthy and potent life.

The comprehensive list next points out that dreams of gladiolas represent heartache, serving to remind you that love hurts, and following after gladiola in this dictionary is gladiator. Dreaming of yourself as a gladiator suggests that you are fighting for survival, and surrounded by others who are working against you. You can quickly move on from this paranoid and troubling scenario to the next example, dreams that feature glass.

There are a number of graphic interpretations to select from. Simply, you may be putting up a barrier to protect yourself in a relationship. But if the glass is dirty or cloudy, it suggests you're not seeing things clearly. To see broken glass signifies disappointment and negative changes in your life.

Should you dream of eating the glass, it highlights your vulnerability or

confusion. Alternatively, it may symbolise hurtful and cutting comments you have made, that you feel guilty about.

Seeing glass suddenly shattering is a more positive image – it points to major breakthroughs in some area of your life, a great obstacle you have overcome. Best of all is to dream you are drinking water from a glass. This is a powerful sign of good luck.

This quick scan of some of the 'G's' in the *Dream Dictionary* may encourage you to seek interpretations of all your nightly meanderings.

Or more likely, it will persuade you that it is all rather predictably obvious and infantile, rendering the 'interpretations' worthless.

I wonder if you ever sleepwalk? Many people apparently do, with reports of sufferers found traipsing miles from their home, barefoot in pyjamas.

The three million people in the UK who occasionally sleepwalk describe waking up in a different room from where they fell asleep, or find themselves having a bath, or snacking at the kitchen counter.

As one respondent explained, 'when under stress, I sleepwalk and hide my things that are necessary to get ready for work. In the morning when I wake, I have to spend 15 minutes trying to find the hidden items'.

Others drove their cars while asleep, and found themselves waking many miles away, in a parking lot, or an unfamiliar road.

A lady reported that she was so fretful before going to bed, that in her sleepwalk she got up and lit the gas heater in her tiny apartment to full blast.

When she woke in the morning, it felt as if she was in a sauna.

But remember, some of our greatest inventions were created because they actually came to people in a dream.

Larry Page had the idea for Google, Nicholas Tesla the notion of alternating current, James Watson discovered the DNA double helix form, Dimitri Mendeleyev envisioned the periodic table, Elias Howe's invention of the sewing machine – all these advances came about after being formed in a dream.

For us ordinary folk, best stick to dreaming of tall African wildlife, or better still, ginseng.

Our feet are getting bigger.

People's feet are growing so fast that average shoes have grown by two sizes since 1975. Retailers who used to only stock men's footwear up to size 12 are now offering size 14 as the upper limit. Size 6 is the new norm for women, and size 10 for men.

Why this remarkable spurt in foot size? People are simply growing bigger, taller, and heavier in these modern times, and this extra weight we carry clearly requires larger feet.

Starting from early childhood we are bulking up more quickly than earlier generations, with fuller stomachs stimulating growth hormones.

Our bellies are increasingly being filled with high-density processed foods, pizzas, burgers, crisps and sweets.

Bigger bodies have caused our feet to compensate, growing longer and wider over the decades, splaying out to give us more support.

As obesity becomes more widespread, experts predict escalating growth in shoe sizes, to further complicate life for footwear manufacturers and retailers.

One important fact should be noted by gentlemen with daintily proportioned feet. There is nothing behind the disobliging supposition that a link exists between foot size and penis length.

Researchers at St Mary's Hospital and University College Hospital in London measured 104 men of all sizes and determined that there is no

correlation between the two.

Feel assured, then, that despite your feet being dwarfed by those belonging to world record holder Matthew McGrory, who wears a size 26 shoe, there is no reason whatsoever to feel diminished by other aspects of his anatomy.

If our bodies continue growing as they have, perhaps in years to come his size feet will be deemed merely normal.

During an average day of walking the total weight your poor feet have to bear can total hundreds of tons. It's your toes that have to bear the brunt. Each time one of your heels lifts off the ground it forces the toes to carry half of your body weight.

You have probably wondered at some time why people can have problems with smelly feet? Alarmingly, feet contain 250,000 sweat glands, more than any other part of your body, as well as the dozens of muscles, tendons and ligaments needed to carry you.

While the sweat itself doesn't smell, socks and shoes can trap odour-causing bacteria, which thrive in damp, dark conditions.

The cheery news is that the smellier your feet, the more chance you have of winning a cash prize. Odor-Eaters, which makes smell-neutralising insoles, holds an annual Rotten Sneaker contest, with entrants invited to submit their most unpleasant smelling gym-shoes. The most recent winner was a nine-year-old boy with a pair that presented an arrestingly robust fragrance.

Surprisingly, there is now clinical evidence that feet grow larger during the day. By evening, many women dread squeezing into flattering designer heels, knowing that they will become increasingly uncomfortable as the night draws on. But don't always blame the shoes – it is usually just your feet getting bigger as the hours pass.

However large our feet may grow, we are still unable to compete with some other inhabitants of the planet – who are adept at skills we cannot begin to emulate.

Butterflies, for example, can taste with their feet.

Now that's a trick I'd like to try.

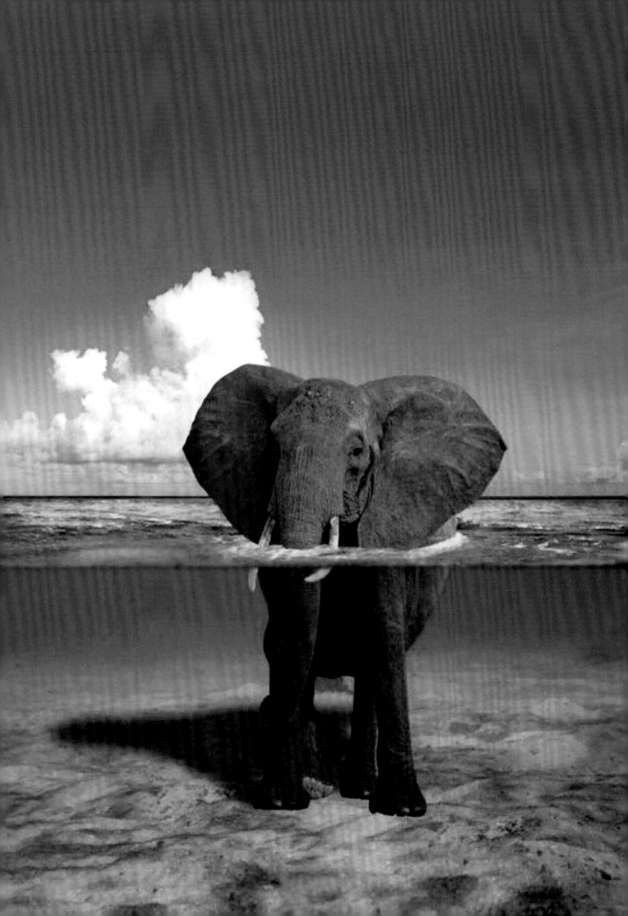

He can swim better than you.

Even if you happen to be an Olympic swimming gold medallist, an elephant can probably out-swim you.

They can manage 20-mile ocean crossings in a day, using their trunks as snorkels, as they swim gracefully from island to island in the Indian Ocean.

While we applaud Olympic gold-medallist Michael Phelps's 1 minute 42 seconds for the 200m freestyle, this is a little tardy compared to a perfectly streamlined sailfish.

The fastest marine creatures, they have been clocked at almost 70mph, able to win the 200m race in about 10 seconds.

But unlike Mr Phelps a sailfish has the ability to leap in the air, where it moves even swifter than it does in the water, literally flying.

Coming in at second place for a silver medal would be a swordfish, a marlin or a yellowfin tuna, at 45–60mph, followed by a killer whale, swimming at 35mph.

The killers use their speed to catch other whales as prey, hunting in all the world's oceans from the chilly Arctic and Antarctic regions to warm tropical waters.

Everyone's favourite sea mammal, the dolphin, can reach a speed of 24mph, closely followed, rather surprisingly, by the hefty leatherback turtle.

While it is unlikely that an overweight man could win an Olympic swimming title, this correlation does not apply to sea turtles.

Recent studies have shown that slender turtles are actually slower than their tubbier cousins.

Apparently, plump turtles are able to get more out of each stroke – comparatively fit-looking turtles move their flippers closer together as they swim, causing them to lose power.

Alongside elephants, there are some other unexpectedly good swimmers in the animal kingdom.

Tigers contradict the general belief that felines tend to dislike water; they are very adaptable and thrive in the wildly differing habitats of freezing Siberian winters, or humid Indonesian tropical forests.

In the Sunderbans in Bengal, Tigers are regularly seen swimming from beach to beach, comfortable sharing their environment with saltwater crocodiles.

Have you ever seen the swimming pigs in the Bahamas? I am not referring to some of the more unsightly tourists the islands attract, but to the friendly inhabitants of Pig Island.

These Bahamian pigs rush into the water as soon as they see a passing yacht, in the hope of grabbing a free meal.

They have made the ocean central to their daily lives, and swimming an everyday activity.

The octonaut spider certainly swims proficiently, but can also scuba dive. They submerge for up to 30 minutes by trapping air in their abdomen's water-repellent hairs.

They drop under water to avoid predators and to look for food – these aquatic spiders not only feed on flies but also have a surprising fondness for fish.

Charmingly, elephants appear to swim simply for pleasure, particularly when they are youngsters.
Y outhful elephants also enjoy diving and like to climb onto the backs of older family members and plunge back into the water.

Thoughtfully, for a zoo, the Fuji Safari Park in Japan decided to try to make life as congenial as possible for the elephants housed there.

It created a 65m tank so their elephants can enjoy a dip whenever they like and are able to display their swimming prowess.

Now if only they could master the backstroke…

An angry old bag.

It is oddly depressing to examine the variety of reasons that make people upset.

Obviously, anger comes in many forms, and can grow from mounting irritation to the kind of thunderous rage that involves two cars, two drivers and a policeman.

Anger seems to be an endlessly fascinating emotion for psychologists to unravel.

In a new study published in *Psychological Science*, researchers bizarrely found that associating an object with hostility actually makes people desire it more.

We think of acrimony as something to try and avoid.

But anger activates an area on the left side of the brain that is associated with many positive drives.

Henk Aarts and his team at Utrecht University conducted a study with each participant watching a computer screen while images of common objects, like a mug or a pen, appeared on the screen.

The volunteers didn't realise that immediately before each object appeared, the screen imperceptibly flashed either a neutral face, an angry face, or a fearful face.

This subliminal image tied an emotion to each object.

The subjects in the experiment had to squeeze a handgrip to obtain the objects they desired most – those who squeezed harder were more likely to win it.

People put in far more effort to obtain objects associated with angry faces. "This makes sense if you think about the evolution of human motivation," says Aarts.

"For example, say there's limited food in the environment.

"In such a context people associate food with anger, and turn aggression into an attack response, in order to get the food they need to survive.

"Without aggression in your system, you may lose the battle and starve. "But," reports Aarts, "when you ask people why they worked harder to get the object they tried for, they say, 'It's just because I like it'.

"That shows how little we know about our own motivations."

Apparently, there are four basic strands of anger:

Aggressive Anger, that leads to fighting and the wish to attack others.

People will often express hostility first as a threat, using both attacking words and combative body language.

Defensive Anger, when the initial emotional response to threat is fear, leading to the courage of desperation.

When this turns to fury, the defensive person may appear as an aggressor.

Outraged Anger grows when people are thought to be breaking the informal moral codes of conduct expected in civilised society, e.g. the indignation felt when somebody is callously uncaring to someone handicapped.

Frustrated Anger, when things do not go to plan and we can become discouraged and annoyed.

We tend to vent our displeasure on innocents unfortunate to be nearby.

On a more prosaic note, here are the more common triggers that research identifies make us cross.

They are in no particular order – different people are driven to fume by any number of petty irritants.

People who take credit for your work. Slow-loading computer screens. Lies and liars. People talking to you while you are clearly occupied. Screeching children. People who talk, munch and slurp during movies. Nosy, prying people, and those who look over your phone while you are texting. People borrowing something and returning it broken. People who smell. People who eat with their mouth open. Surly shop assistants. Overseas call centres. Queue jumpers. Dawdling walkers. Junk mail. Text message speak. Selfish parking.

All things considered, it's a wonder we don't all live our days in a murderous strop.

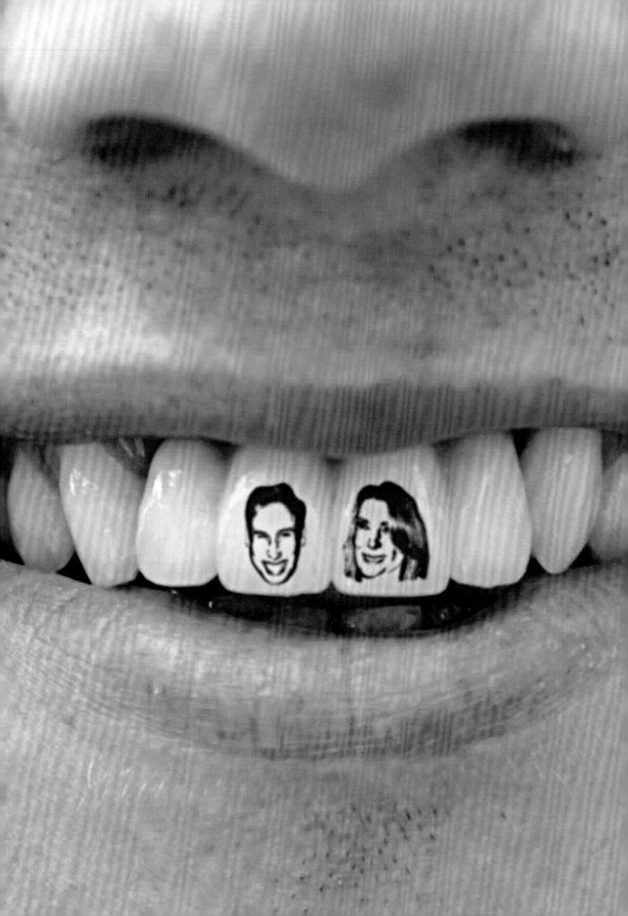

Give your teeth the royal treatment.

Do you admire members of our Royal Family deeply enough to have them tattooed on your teeth? You would be bewildered, and alarmed, at the levels of devotion our Royals attract.

Around 40% of Britain's most dangerous stalkers focus on members of the Royal Family. Buckingham Palace receives 10,000 letters a year from people classified as suffering from mental illness.

This post regularly contains violent threats, and the Queen in particular has been targeted by unstable cranks.

Some of them believe that they in fact are the real Queen, and that Elizabeth has usurped their throne.

Prince William is the object of obsessive fascination by women who find themselves tenaciously infatuated with him.

More worryingly, the Duchess of Cambridge required a specialist police team to monitor the 220 stalkers believed to present a threat to her, even as she prepared to give birth to her second child in April 2015.

Officers and psychiatric nurses interviewed the more high-risk fanatics to carry out threat assessment checks.

Creepily absorbed royalists are not a modern phenomenon by any means.

Edward Jones broke into Buckingham Palace at least three times while Queen Victoria was in residence.

He would prowl the private apartments, rummaging through the monarch's belongings, and was even once caught red-handed with several pairs of the young queen's underpants.

He was acquitted by a judge, who deemed it a harmlessly amusing prank.

You will remember Michael Fagan, who managed to scale a drainpipe and waltz into the Queen's chambers in 1982.

She awoke to find him perched at the end of her bed, his hands cut and covered in blood.

Unable to reach security officers, Elizabeth engaged her intruder in conversation for about 10 minutes, listening to his personal problems, until a chambermaid and footman fortunately checked in on her.

Fagan, who was ordered to spend six months in a mental hospital, had crept into the royal residence just weeks earlier, making off with a bottle of Prince Charles' white wine.

So great is the allure of the Royal Family, analysts have studied over 20,000 incidents involving one or other of them being stalked.

A new study conducted on people who are unhealthily bewitched by the monarchy was published by *Psychological Medicine*.

Apparently 80% suffer from various clinical problems including schizophrenia and hallucinations.

The report arrived at a classification of the different types of stalker, by motivation. These include: Delusions of Royal Identity, Amity Seekers, The Intimacy Seekers, Sanctuary and Help Seekers, The Royally Persecuted, The Chaotic .

A sympathetic view has traditionally been taken towards these ultra-fans. They were considered harmless and lonely individuals, clearly in need of care.

That is certainly no longer the case – some are viewed as posing a persistent danger. Of course, devout fans of our Royals are not restricted to people who live in Britain.

An Australian follower, Jan Hugo, spent hundreds of thousands of dollars amassing a collection of around 100,000 pieces of Royal Family memorabilia.

Besides a great deal of commemorative porcelain, her treasures even include a replica doll of Prince George, which lies in pride of place in his brass cradle, overlooked by two life-size mannequins of his parents.

Perfectly charming I am sure, but my favourite of the Royal superfans remains the gentleman pictured here, with his exquisitely regal smile.

Looking for a haystack in a needle.

Have you found what you're looking for?

So many of us never do, leading frustrated lives, always searching for some elusive elixir of happiness.

Routinely, it's the desire for great wealth, or a fantasy notion of perfect love, or a glittering career that earns respect wherever you go.

How much easier to have less lofty expectations, with goals that are more easily attainable?

In fact, research shows that happier, more fulfilled people are those who don't struggle too hard with unrealistic ambitions. A study at the University of Texas found that conventionally 'successful' people don't make life choices that lead to happiness.

It noted that the more visible their achievements, such as promotions, pay rises, homes and possessions, the more unfulfilled and distracted they become.

Instead, the key is to take a more practical approach, by knowing where to look. It was found that five key areas can have great impact on our wellbeing, and they are all in our own control.

Central to being happy is to prioritise happiness, rather than chasing it, and the difference is vital.

First, experts recommend, people should recognise the things in life that make them happy, and concentrate on those.

It might be spending time with friends, going to bed early or reading a

book, but whatever it is, people should ensure they make time for it.

Secondly, people should accept that they are largely in charge of their own happiness, and that it is something they can take more control of.

In an age of social media and constant updates from those living seemingly perfect, digital lives, it is important not to fall into the trap of comparing yourself and your happiness to others.

While it might seem that people are motivating themselves by setting aspirational targets, it often leaves them feeling unhappy – there will always be someone on holiday while you're stuck at work, or someone else achieving something you have yet to. The goalposts will never stay still.

Trust plays an important part in our search for happiness – the more we trust people, the happier we are. The study suggests that we should try being more open – talk to a stranger each day and focus on the positive aspects of the people you know, rather than their irritating qualities.

The World Happiness Index surveys populations from across the planet to find which countries have the most contented citizens.

It asked subjects to rank their happiness, and weighted the answers based on six other factors: levels of GDP, life expectancy, generosity, social support, freedom, and lack of corruption.

Sadly, Britain ranked a lowly 23rd – but that is higher than France at 32, Spain at 37, Italy at 50. Heading the Index is Denmark, with Iceland, Norway, and Finland in the top 5 along with Switzerland. Canada follows at 6th. America at 13 seems to be considerably happier than we are.

Interestingly, studies show that 79% of Danes trust 'most people.' This is certainly influential in helping it be a generally relaxed nation, regularly at the top of the chart. They don't spend their time dreaming of sublime, perfect days, carefree and untroubled by the humdrum burdens of everyday existence.

They are simply more accepting of the basic notion of a life well lived.

Languishing at 53 is Japan, with some of the most miserable people on Earth.

Perhaps, too many of them are looking for needles in haystacks.

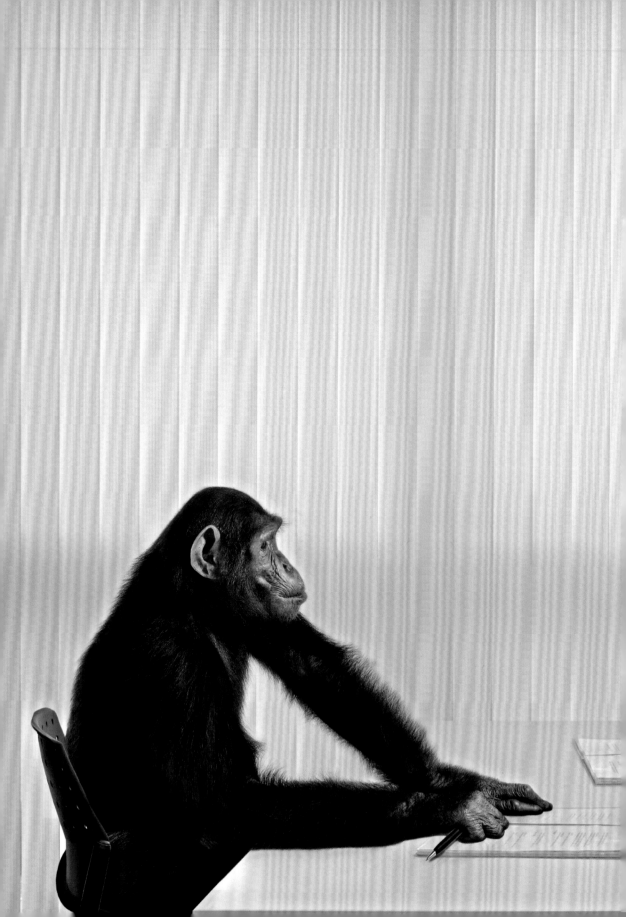

Is this you in an interview?

Most of us feel incoherent and dimly half-witted in job interviews. Usually it is just our nerves, shredded for hours before the meeting even starts.

Interviews are discomforting at best, and unbearably stressful at worst – often deliberately so. Candidates are routinely asked impossibly perplexing questions, with no simple correct answer.

For example, seeking a post at Google as an admin assistant, a hopeful young lady was asked, 'If you are given a box of pencils, what are 10 things you could do with them that are not their traditional use?'

A potential recruiting manager for Amazon was expected to answer, 'How would you solve problems if you were from Mars?' An intern applicant at Apple had to explain, 'What's the most creative way you can break a clock?'

As you can see, tech companies are consistently among the most testing of interviewers. Twitter, for example asked, 'Why should we not hire you?'

Recently, Google stated they were abandoning riddle-style interview questions. A spokesperson admitted they were used to test their potential employee's ability to think unconventionally, and to see if they were quick-witted.

'We have now moved away from these types of questions because candidates hate them, answers leak easily, and more importantly, research on the connection between being able to solve a brainteaser and future job performance, or as an indication of a candidate's IQ, is questionable and inconsistent.'

Forbes business magazine helpfully offers some suggestions for answering the

toughest interview questions you are likely to face.

'Why should I hire you?'

Most people are unsteady at explaining why they are particularly qualified.

They haven't done their homework to identify the skills that the job they are seeking requires, or aren't set to draw on their past experience to demonstrate their suitability.

'Tell me one thing you would change about your last job?'

Beware of making disparaging comments about your former employer or co-workers. Be ready with an answer that doesn't criticise a colleague, or make you appear a whinger. A safer route to take is to mention outdated technology, if you can turn that to your advantage, and show how in touch you are with fast-developing tech opportunities.

'Tell me about yourself?'

People find themselves meandering, with too much personal background.

Restrict your answer to a minute or two, covering your education, work history, and most recent career experience.

This is likely to be a warm-up question, so just move along efficiently, saving your best arguments for the more probing questions that will follow.

'What would a person who doesn't like you say about you?'

Highlight an aspect of your personality that could initially seem negative, but that can be subtly translated into a positive. For example, impatience; suggest that you are very committed to meeting deadlines, you feel that timeliness is important in any management team, and you can be a stickler for it.

'You have changed careers before, why should I let you experiment at my company's expense?'

You should answer that as a career changer, you have become a better employee because you have gained a lot of diverse skills.

It helps you solve different kinds of problems creatively, and your experience has guided you to seek this particular position, because you feel it is ideal for your long term future. It's a harrowing business, being grilled by experts.

The best advice? Remember the Boy Scout code, and be prepared.

Every day, our privacy is flushed away.

There are 5.5 million CCTV surveillance cameras in the UK, staring constantly at us.

We have 1% of the world's population, but a fifth of the monitors on the planet, far more than the most authoritarian state, China.

Furthermore, if you don't like being snooped on, stay offline.

Bear in mind that half of the world's population uses the internet, with more than a billion people active on Facebook – and Facebook sells your personal information.

Since becoming publicly traded on the stock exchange, it has needed to find ways to increase profits to demonstrate its value to investors – also buying up Instagram.

As the largest database of people ever created, it contains more private facts than any other source.

Data collection is a $300 billion a year industry, with hundreds of companies peering into your personal life and gathering details about you from online sites. Apparently, this is completely legal.

The information that they are interested in can be split into three types: volunteered data, observed data such as your location and interests, and inferred data – what they have discovered about you after analysing the first two lines of burrowing.

Companies and brands buy this bundled knowledge, enabling them to target you as a potential money-spinning customer for their business.

You will also know that drones hover invisibly over Britain, watching us from unique vantage points.

According to the CCTV Code of Practice, 'Individuals may not always be directly identifiable from the footage captured, but can still be identified through the context they are captured in or by using the device's ability to zoom in on a specific person. As such, it is very important that you can provide a strong justification for their use.'

Disturbingly, the European Court of Human Rights ruled that employers are allowed to read their staff's private messages sent during working hours,

and check on all websites visited on company mobile phones.

Our Government Communications Headquarters – GCHQ – is in charge of the surveillance of all our cyber connections and infrastructure.

Without Parliamentary consultation or public scrutiny, it records the browsing habits of every user of the internet, not requiring legal permission to do so.

They simply tap all of Britain's fibre-optic cables to gather information on an infinite number of people.

Elsewhere, the level of general data gathering has gone so far as to include children.

Smartphone apps are being used by companies who market products aimed at youngsters, to store information about where they go, who they are talking to, and even photographs.

This offers a new perspective on the phrase 'nanny state'.

UK authorities have taken to infiltrating games such as World of Warcraft, populating them with their own programme of characters.

This was intended to keep tabs on suspected terrorists, who seemingly are often keen gamers.

In truth, all this snooping, however intrusive it may be on our privacy, is vitally needed to keep us safe.

It has certainly saved countless British lives by discovering and snuffing out many terror cells over the last decade – before they could create more 7/7s, or worse.

But the most worrying escalation in people-watching is the news that governments have been able to secretly spy on citizens through their computer webcam – without activating its recording light.

Bewilderingly, you can even be remotely monitored via your TV.

You can be sure your smartphone is next. But in truth, only if you are considered a real and present danger to the rest of us.

The road to nowhere.

Are you stuck in a dead-end job?

If you don't jump out of bed in anticipation of getting to work – or worse, if you wake with that Monday-morning-feeling on most days, it's time for a firm talk with yourself.

Most of us want careers where we can learn, grow, make more money, and climb higher. When our job feels static, and the daily routine mechanical, when we see no way to move ahead, or gain responsibility – it's easy to fall into apathy, resigned to the status quo.

To avoid any self-delusion, you can be certain your job is going nowhere if:

1: You are offered very few ways to move ahead with more challenging projects. Colleagues are getting opportunities ahead of you, and you are overlooked for promotion.

2: Your superiors show little interest in your career goals or future ambitions, or are hard to pin down about prospects going forward.

3: You are not treated as an asset to the team, your views are largely unheard, and your opinions appear to carry little weight. Even if you move mountains to succeed in a task, the silence that follows is deafening.

4: Your company routinely hires new staff from outside when new positions open, rather than promoting from within.

5: Your skills are not being tapped, you are not being groomed for advancement or offered new training.

6: Your employer is itself sinking, profits are stagnant or falling, your industry sector is not growing, the management are not inspired or creative enough to re-build.

7: Even if an opportunity arises, you may not even want it – not if it means extended hours, or heavy bouts of travel to dull cities.

8: In short, if you wouldn't want your boss's job, you could be trying to climb the wrong ladder.

The primary reason people hang on to unsatisfactory jobs is fear of the unknown, because the unfamiliar and the upheaval makes us nervous.

How can you make uncharted territory less daunting? Remember, if you only do what you already know how to do, your world grows pretty stale.

Before you undertake a complete makeover of your career, know the alternative you are considering thoroughly. Learn about it, research it, talk to people in that field at all levels you can. Check out the prospective company on the Glassdoor site.

Shine some light onto the unknown, and hopefully if you're still drawn to it, it is more likely be a good fit. You probably need to keep your current job during the transition to another career, as you go job-hunting while at work.

That means you need to be quick and efficient to avoid letting-down your current employers. Sign up for notifications from job sites that have positions you might want, so that you are alerted of anything suitable.

More businesses today are accepting applications online, allowing you to deliver your compelling initial pitch out of working hours.

Prospective employers can only physically meet you during the week, so try to group as many interviews in a single day as possible, taking it as holiday, or a sick day if you must. This avoids sneaking off for mid-day interviews.

No matter how depressing your current position may be, don't burn any bridges. Whether it's for a decent reference now or in the future, your old employer may come in handy, so try to avoid any ill feeling.

Bear in mind, one day you may be back to buy the company, and run it much better.

Are you a fine parent?

Who are the worst people on Earth?

If you get nauseous with disbelief, filled with mounting rage when you read of the horrors some poor babies and children are subjected to – it's their viciously sadistic parents who would come top of the list.

It seems there truly are real monsters living among us. Capable of inexplicable cruelty to their offspring, routinely torturing them to death, they often get away with milder prison sentences than people who cheat on their VAT returns.

Meanwhile, normal mothers and fathers fret about their day-to-day parenting skills, concerned that they are raising their children the correct way.

They want their young ones to grow up secure and confident, and instilled with sound values – in a happy childhood to look back upon for the rest of their lives.

However, setting boundaries is a requirement of parenting, as hard as they might be to set. Parents don't actually want to punish their children, and so often resort to one, two, three or more increasingly dire warnings.

This may work to avoid friction, but in the long term it makes your child see you as easily manipulated and unreliable.

Instead experts suggest, try to change your own behaviour. Set the limits, communicate the consequences, and then follow through if it is necessary.

Create the lines you do not want crossed, that you are able to enforce

consistently, without making you feel stressed.

We set physical limits to keep them out of danger, but as they grow those limits are no longer always in your control, so it is vital that they know what is acceptable and what is not. It helps children feel secure, and develop a sense of responsibility for their actions.

Children start negotiating surprisingly early. Unfortunately, negotiation often feels like a battle, and it may seem easier to give in and let them have what they want in exchange for a few more minutes of peace and quiet.

But regularly caving-in means that you have given up – and are no longer guiding your child towards responsible behaviour and good decision-making.

In the end, it will make them lose respect for you.

Communication and listening to their point of view is key, but sometimes the short answer is just "no", and the long answer is "no way".

Demonstrating your firm resistance to being budged will save you hours of wasted time on exhausting, convoluted arguments.

Specialists ask you to always remember that bribery is one of the worst habits that can sneak into parenting.

Your child will demand extra rewards for doing what they should be doing anyway, and you will feel a sucker for giving in to pester-power, buying-off their bad behaviour.

It is also counterintuitive to spare children any chores. Household tasks are not a punishment; children will gain a feeling of responsibility that begins to prepare them for adulthood.

As children grow, they need more freedom from parental protectiveness.

They must make their own decisions and cope with physical and psychological separation from you.

Many of these guidelines can be hard to accept when you have viewed this small human as your best friend for so many years. It's the trap many parents fall into. Your child is not your best friend while they are growing up.

But they are more likely to become so as they approach adulthood – if you relax and let them handle their obligations, and guide their independence.

Are you the cat, or the mouse?

Personality profiles linking us to types of animals make unpredictable reading.

For example, if you have a 'lion' personality your strengths are that you are a visionary, practical, productive, strong-willed, independent, decisive, and a leader.

All very admirable, but your weaknesses suggest that you are cold, domineering, unemotional, self-sufficient, unforgiving, sarcastic and even cruel.

Perhaps you are more of an 'otter', with strengths that include being outgoing, warm, friendly and compassionate.

However as an 'otter' your weaknesses are disclosed as being undisciplined, unproductive, egocentric, unstable, with a tendency to exaggerate.

A 'golden retriever' personality would suggest your strengths are being calm, easy-going, dependable, quiet, objective, diplomatic and humorous.

But your weaknesses are a bit of a setback.

These include being selfish, stingy, a procrastinator, unmotivated, indecisive, fearful and a worrier.

'Beaver' personality types are skilled at being analytical, self-disciplined, industrious, organised, aesthetic, sacrificing.

But weaknesses include being moody, self-centred, negative, unsociable, critical and revengeful.

The conclusion appears to be that all of us, however admirable, are flawed

in a number of ways – but hopefully only to a minor degree.

Some animals, including humans, tolerate challenges better than others.

A zoo in Seattle looked at how various species cope with rain.

Orangutans wrap burlap bags around themselves, squirrels and mice huddle, while other animals simply retreat.

Grizzly bears, on the other hand, usually remain out in the open and try to put up with the wet conditions.

They will often do that, the zoo noted, even though they could go into an enclosure.

If you are very musical, you may relate to a goldfish.

They are quite intelligent, and not only enjoy listening to music, but can also distinguish one composer from another.

A study published in the journal *Behavioural Processes* involved playing two pieces of classical music near goldfish in a tank.

The pieces were Toccata and Fugue in D minor by Bach, and The Rite of Spring by Stravinsky.

The goldfish had no trouble distinguishing between the two composers.

Are you prepared to admit that you may be a bit vain?

Unsurprisingly, this links you to a peacock.

Male peacocks sing, strut, and dance in front of often blasé females, who look a bit full of themselves too.

The elaborate show draws attention, but not always from the right viewers. All of the dancing and prancing can alert potential predators that an easy meal is near.

Wild peacocks make quick snacks for jackals, tigers and hawks in their native habitat in South Asia.

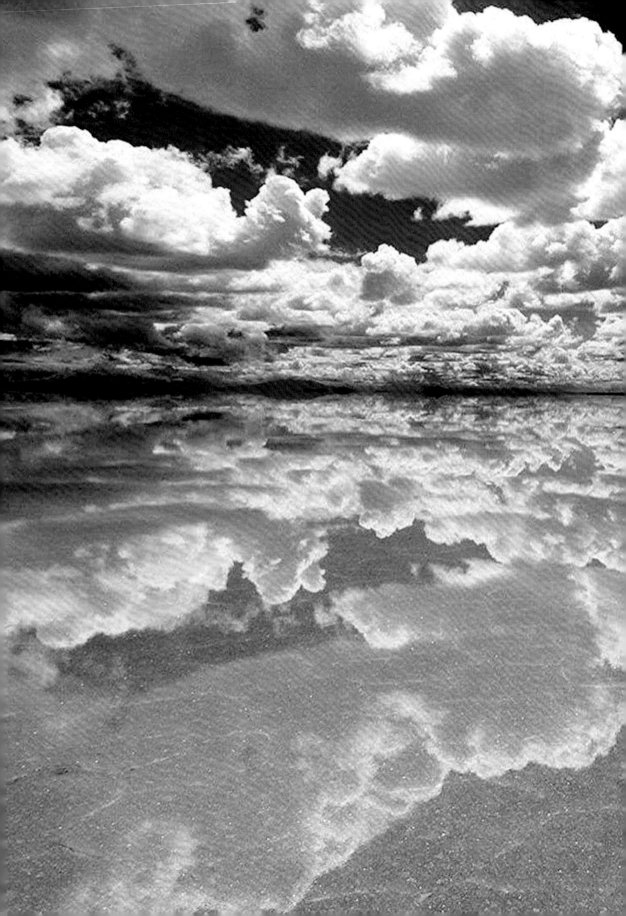

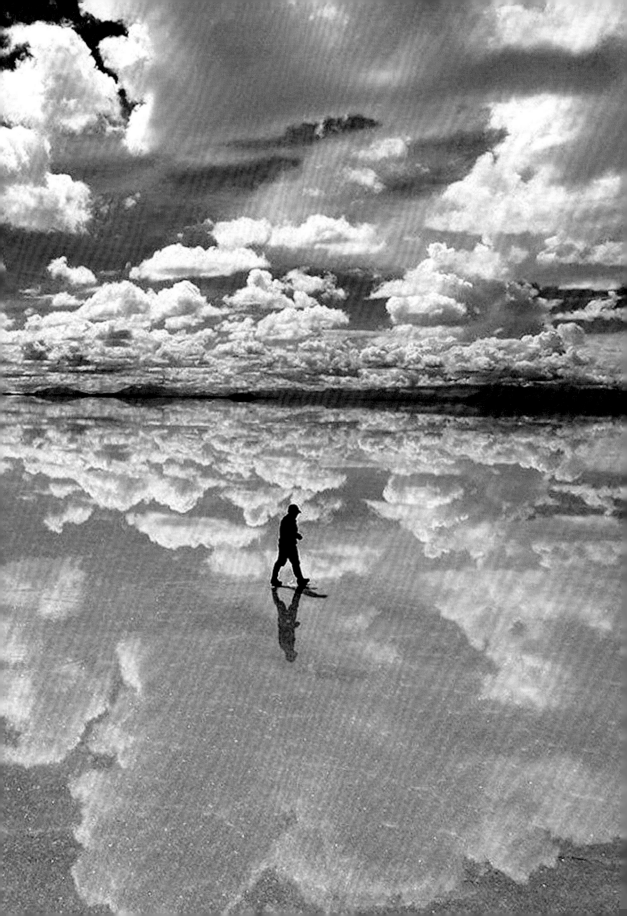

Every silver lining has a cloud.

You don't have to be a diehard pessimist, or a full-on misanthrope, to know that bad is never good until worse happens. Many people are nervous about a run of great luck, in case the Evil Eye is watching, and will pay you back with a hearty bout of misfortune.

But according to *Psychology Today*, people for whom the glass is always half-empty, those who regularly sense storm clouds looming overhead – these are the people who make better leaders. Their very cynicism leads to realistic expectations, and the report takes the view that this could be the recipe for happiness.

'Given that we are in an optimistic culture, in the workplace for example, you don't want to be labelled as the person who's always negative,' noted Dr Julie Norem, a leading psychology professor. 'But I think there's some rising awareness that you need that perspective in group decision making.'

Most of us exist somewhere between the polar ends of the personality spectrum, neither blithely optimistic, nor reliably pessimistic.

It might seem like an optimist's world. Whether it is the fictional characters in a book, or our colleagues and acquaintances, we are more at ease with people who have a sunny disposition. Nonetheless, a Pollyanna's boundless good cheer may begin to grate after a while, particularly when times are difficult, and our patience becomes stretched.

Optimists feel that they are in control – the most pivotal difference to

pessimists. Their belief that they can shape the future for themselves makes failure more difficult to accept, whereas pessimists continue to march on, more accepting than affected. Another benefit for pessimists is often an extended lifespan, thanks to their cautious sensibilities.

Being overly optimistic was 'associated with a greater risk of disability and death within the following decade. A refusal to see the negative could end up putting you in harm's way.'

Pessimism however, encourages people to 'live more carefully, taking health and safety precautions.' It has also recently been shown that in long-lasting, close relationships, a little pessimism could be the magic ingredient.

A report published in the *Journal of Personality and Social Psychology* found that over-optimism puts couples at risk of 'marital-deterioration, mostly because they don't actively problem-solve.'

Instead, they force themselves to stay positive in dealing with distress, and end up hurting one or other of the partnership. Surprisingly, it was found that thinking negatively has been shown to help maximise success from school onwards.

Apparently, people who approach a potentially stressful event by imagining everything that could go wrong tend to perform well. Is it because they have pre-empted and prepared themselves for any otherwise unforeseen obstacles?

Or is it because their natural tendency to envision the worst means that they are exceptionally motivated to try harder?

It is certainly the case that a fully-fledged cynic understands that you can't fully appreciate life's highs without experiencing its lows.

As any sourpuss or killjoy will drum into you, ill-informed optimism deludes people into ignoring reality. Yet a prophet-of-doom mind-set can draw people into depression and inaction.

The more Pollyanna of us would argue that we need to embrace both reality, and faith.

Their argument? In unpleasant circumstances, having faith that you will ultimately prevail is one of the best ways to ensure that you do.

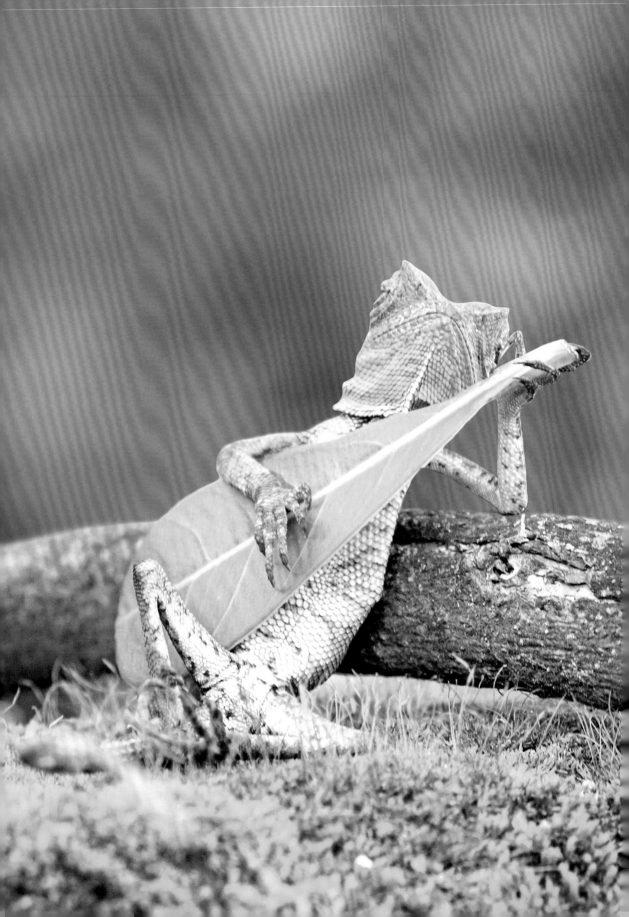

The musical wizard lizard.

Spotted by a professional photographer in Indonesia, the lizard here appears to be practising his chords.

"I watched it for an hour, not taking any pictures until it felt calm and comfortable around me.

"He seemed to be stroking the leaf as though it was a guitar," the cameraman explained.

If you failed to take up a musical instrument in your youth, and feel it's now too late, don't fret.

A recent study has shown that starting to play an instrument late in life has valuable medical benefits, helping to ward off dementia in the elderly – even if you start at age 75, or in retirement.

Associations have been set up purely for those over 55. One member credits her new pastime of playing the organ for a quick recovery after brain surgery.

Of course, there are those who battled through great handicaps to create some of the world's most recognised music.

We know that Beethoven overcame immense physical shortcomings to produce his immortal music, but contemporary musicians like Ray Charles and Stevie Wonder wrote and recorded popular classics despite improbable odds.

The great Handel suffered from a stroke that left him paralysed and almost mute. According to his doctor, 'We may be able to save the man, but we have lost the musician.'

But Handel never gave up, and went on to begin his greatest masterpiece, The Messiah, working relentlessly until it was finished.

He suffered further strokes but these didn't halt him for long, until he died at 74, now additionally blind.

Django Reinhardt, the legendary Belgian guitarist, started his professional career at age 13 when a young gypsy.

It allowed him to make ends meet, but left him no time for education, and he was illiterate for most of his life.

At 18 his caravan caught fire, injuring his right leg and left arm so badly

that he barely managed to convince doctors not to amputate them.

Even so, they told him that he would never play the guitar again.

But Reinhardt re-learned to walk using canes, and trained himself to play the guitar once more, using the index and middle digits of his left hand, his only functioning fingers.

Soon, his creation of "hot jazz guitar," was born.

Musician Tony Iommi also lost the tops of the middle and ring fingers of his right hand, while working at a sheet metal factory.

For any another guitarist this would clearly have been a calamity, but once he learnt that the great Reinhardt played with just two fingers, Iommi was inspired.

He changed the way he set up his guitar to avoid hurting his damaged fingers.

Using thin-gauge banjo strings, he tuned them looser than usual, because tightening them too much was unbearably painful after a couple of songs.

He started to use thimbles to help alleviate the sensitivity, and these enabled him to press down on the strings extra firmly.

Suddenly, he discovered he had created a new sound – dark and booming, it sounded as if it came from the depths of Hell – and heavy metal and death metal were born.

His band Black Sabbath all tuned their instruments lower to match his, and it propelled them to leadership of this new global genre.

Whether you are a fan of this ear-torturing musical cult or not, let us agree to salute Iommi's perseverance and creativity – he is a worthy disciple of Reinhardt, whose wrecked fingers made him such an unlikely guitar hero.

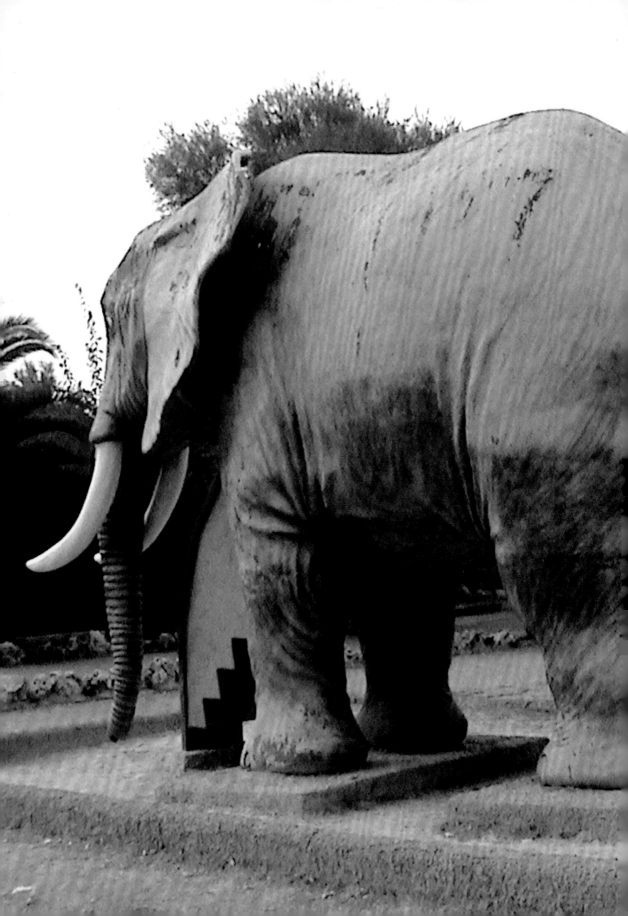

Gross? Not if you're a 5-year-old.

Barbie dolls are considered spookily absurd by most adults.

Troll dolls are seen by the majority of us as grotesque, and Bratz dolls as simply obnoxious. But grown-ups are capable of equally questionable taste in their own toys and trinkets. And it seems that the richer you are, the more spectacularly exotic will be the products created for your delight.

Victoria's Secret offer their 'Fantasy Bra' featuring many precious stones that include 142 carats of diamonds, pearls and aquamarines. It costs $2.5m.

Each brassiere takes 500 hours to be painstakingly fashioned – and it is clearly considered excellent value by their most fastidious clientele.

For gentlemen of cultivated taste, you may consider a pair of Fonderie 47 cufflinks, the world's most expensive currently available, at $32,500.

Each set are lovingly crafted from the metal of used AK-47 rifles retrieved from Africa, and they can also double up as exquisite bracelets.

Or perhaps some 22 carat gold shoelaces by Mr. Kennedy? Only 10 pairs have been produced, in a limited edition at $19,000. They are recommended to be worn with a suitable pair of Christian Louboutin snakeskin trainers at $2,000.

Please cast aside your Gillette Fusion ProGlide, and treat yourself to the outstanding shave promised by a Zafirro razor.

It features sapphire instead of run-of-the-mill stainless steel blades, each 1/10,000th the width of a hair. The medical-grade iridium handle surely makes the $100,000 price tag perfectly reasonable.

A Jack Row pen may be just for you. Studded in diamonds and set on white gold, it combines both Islamic design and modern London architecture, and is attractively priced at just $43,500.

If you are sporty as well as stupidly rich, Louis Vuitton can provide an excellent skateboard. For $8,250 they offer a beauty, covered in colourful graffiti for the required urban look. Desirably, it is also embellished with the Louis Vuitton monogram pattern.

A lady can never have enough high heels, they say, so don't miss out on the enchanting ones offered by Christopher Michael Shellis.

Crafted out of solid gold and decorated with 2,200 brilliant-cut diamonds, they are irresistible to the discerningly genteel woman with $218,000 to spare.

To help keep your look more authentic and contemporary, wear them with a backpack made of alligator leather by The Row, yours for just $50,000.

Set your ensemble off with some Dolce and Gabbana sunglasses, the most pricey in the world at $383,000 – naturally featuring a 22 carat gold frame.

Please do not overlook every fashion-forward woman's most treasured accessory. For her adorable little doggy, the Amour dog collar is a stunner.

Forbes describes it as 'the Bugatti of its kind'.

It is studded with 1,600 diamonds, set off brilliantly by an 18-carat centrepiece in white gold, all placed tastefully on crocodile leather. At a cost$3.2 m, it will certainly set your pet apart.

Of course for the children of the extremely rich, a Barbie or Bratz doll will clearly not be appropriate – not after you have spent $3.2m on a collar for your dog. Sometimes, the very wealthy may occasionally wish to attempt bonding with their little ones.

What better than a game of Monopoly, to inculcate them in the merits of becoming a splendid hedge fund tycoon? For just $2m, you can play on a set made of 18 carat gold, with a matching pair of dice encrusted with 42 diamonds; all the properties are set in 165 further gemstones.

It all somehow makes the elephant playground slide shown here appear a little less gross.

Are you scared of your own shadow?

You would be surprised how many people describe themselves as timid.

Men and women are equally frightened by social activities that others find perfectly simple, such as giving a short speech at a celebration.

Many people are nervous of entering a cocktail party, where the only person you know is the person you came with – and what will happen if you get parted...

If you consider yourself shy then you are most certainly not alone. In recent research, a remarkable 40% of American adults described themselves this way.

With figures that high in a population generally considered bold and outspoken, even brash, it is hard to imagine that the figure wouldn't be higher in more reserved Britain.

Shyness is on the rise, and the age of technology may be to blame.

Since the inception of smartphones, video games, and iPads, the opportunities for face-to-face contact has slowly decreased.

For those already hesitant in company, the presence of the omnipresent internet means that the demands of socialising are becoming more easily avoided. The electronic-relationship era supposedly gives us more time, but ironically it has stolen it from us.

Technology has made us more efficient, and redefined our sense of time and its value. It is not to be wasted, but to be used quickly and with a purpose.

Office environments have largely become barren of social interaction.

They are information-driven, problem-oriented, solution-based, with fewer

moments for pleasantries and general banter – people isolated staring at their screens. And of course a number of people only sporadically attend the office at all – they telecommute.

Technology has ushered in a perfect medium for the introverted, a conduit that removes many of the barriers that inhibit the bashful. But has it become a hiding place for those who dread social interaction? Not according to experts who argue the benefits of technology in helping those crippled by shyness.

They see it as "a coping mechanism for deeply inhibited teens".

Social media sites, and instant messaging make social interactions much less threatening, "eliminating the most difficult steps for more hesitant people".

"If you have an interest in anything, the internet makes it easy to find a chat group who shares that interest, and you don't get rejected."

But that internet connection is tenuous at best, according to other studies.

"Take instant messaging, for example, and look at the nature of that conversation. It goes on constantly, but what's really there? It's communicating, but it's not connecting." At some point, they report that, shy teens "have to log off the computer and log on to life."

A revealing study found that those with a reserved exterior routinely conceal roiling turmoil within. Coy people revealed that they are excessively self-conscious, and constantly sizing themselves up negatively.

Whilst their bolder counterparts are meeting and mingling, the introverted are more concerned at how to manage the impression they give.

Of course, there are different degrees of shyness. The most familiar difficulty-in-meeting-new-people-and-making-new-friends shyness can unhelpfully lead from social nervousness, to isolation and depression.

Cognitive shyness can be even more trying. It leaves the subject unable to think clearly in the presence of others, almost a literal brain-freeze.

Conversation is difficult to enjoy, as they simply clam up, unable to think.

This embarrassment is compounded by the fact that others could view them as bad mannered, or at best, simply dull.

At worst, meek to the point of being afraid of their own shadow.

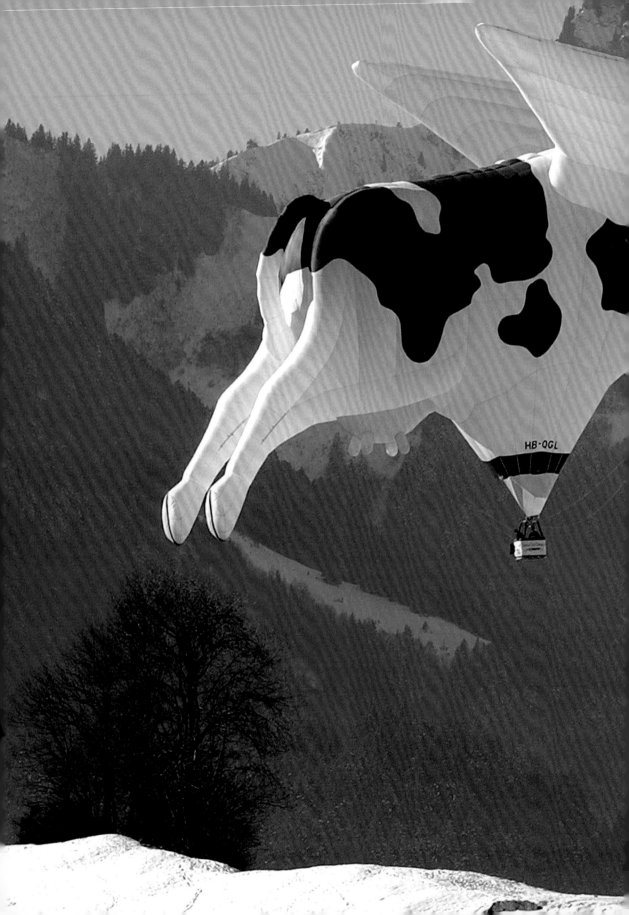

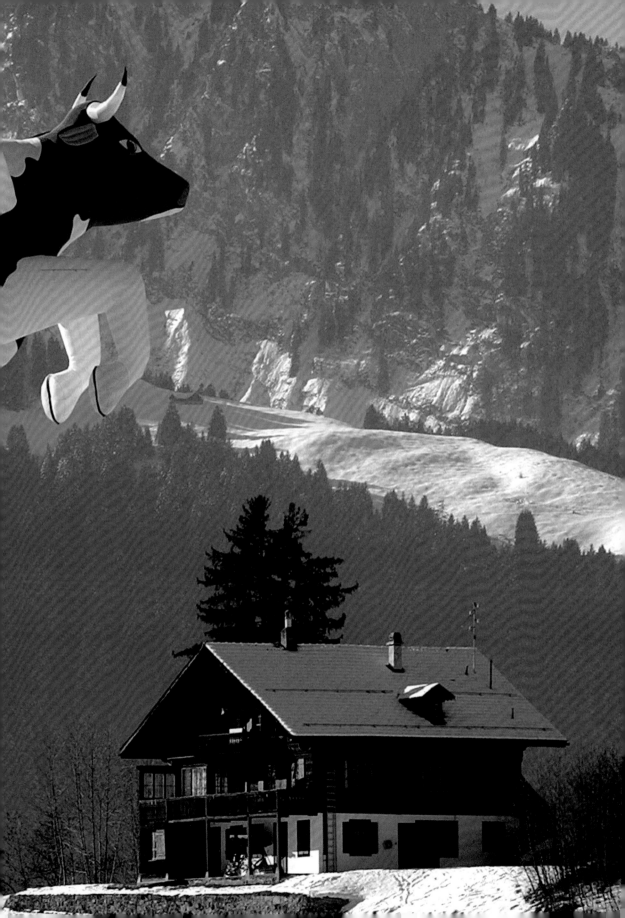

Holy Cow!

Cattle are considered sacred in Hinduism, and revered as a symbol of health, abundance and selfless giving.

So when two artists created an installation entitled Bovine Divine in Jaipur, India – a cow made of Styrofoam suspended from a balloon – they were quickly arrested.

Taken to the local police station for refusing to bring their sculpture down, they claimed the message of the artwork was a respectful one, highlighting the dangers of plastic to cows.

The cattle apparently digest too much of it while scavenging on garbage dumps and poison themselves.

However, outraged protesters urged the police to act firmly, insisting that the floating cow was "portrayed inappropriately".

The work is available for sale, if you wish to install it hovering above your home, and attractively priced.

More worryingly, across the rest of the world the cow is seen by environmentalists as a fearsome enemy.

The UN has identified the rapid expansion of the cattle population as a greater threat to our planet's wellbeing than cars and aeroplanes.

This is apparently due to the emissions they expel.

They are responsible for about 20 per cent of gases that cause global warming, more than all the world's transport put together.

Our 1.5 billion cattle emit so many unwholesome windy pops that they are now officially public enemy No 1. Livestock are producing a vast number of air pollutants, including methane and ammonia, one of the leading causes of acid rain.

Major cow farms are seen as a "leading cause of deforestation", and the endless grazing land cows require is turning a fifth of pastures into deserts.

They also consume too much water, the anti-cow factions claim, citing that it apparently takes 1,000 litres of water to produce a single litre of milk.

There is the additional burden of nitrous oxide, another greenhouse gas, much prevalent in their manure.

And it doesn't stop there. The pesticides and fertilisers used to grow grass for cows to graze, and the hormones that are used to bulk them up, all end up polluting our water.

This washes down into the sea, destroying coral reefs and killing marine life.

Scaremongers often point to the 21,000 square kilometres of the Gulf of Mexico that is officially a "dead zone", unable to sustain fish due to the vast levels of waste from US beef production carried down from the Mississippi.

The fear is that by 2050, the damage done by the planet's burgeoning cow population will double, as demand for food increases.

People are simply eating ever greater levels of dairy and meat products.

In fact, dairy cows produce twice the amount of methane as cows reared simply for their beef – dairy cows release a full payload of expulsions during both feeding and milking.

Experts have studied the problem in precise detail and have determined that the problem is not restricted to cow flatulence – they also belch too much.

But there is good news coming.

A new supplement to cow feed has been developed that reduces the methane produced by 30 per cent.

Nonetheless, cattle farming appears to be an alarmingly hazardous career – compared with merely being a firefighter or a bomb disposal specialist.

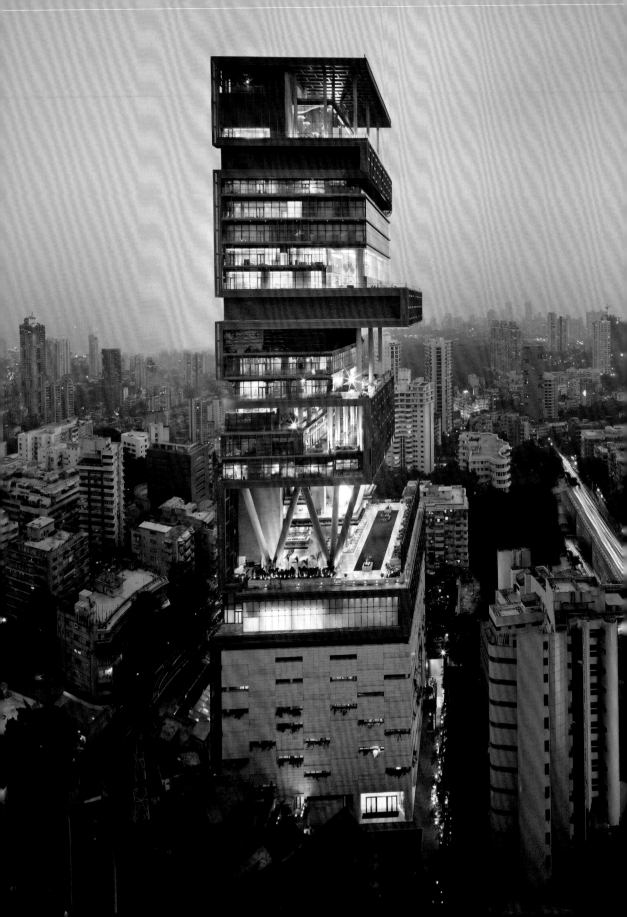

The first £1billion home.

Nestled amongst Mumbai's grim slums is the 27 storey home of India's richest man, Mukesh Ambani.

In reality it is the equivalent to being 39 storeys tall, as many floors have double height ceilings.

Four hundred thousand sq. ft., 600 household staff, a two-storey health spa, a ballroom filling an entire floor, a swimming pool set amongst terraced gardens, 3 helipads, parking for 168 cars, a 100 seat cinema, a temple – this house has it all.

But his neighbours, most of whom share a desperate, meagre existence, don't look up at Mr Ambani in bitterness, or cold hostility at his open display of unfathomable wealth.

They look at him with respect, a symbol of great success and good fortune, someone obviously blessed by the deities.

I wonder how we in London would have welcomed the Shard, if it had been built as the spacious home of a Russian oligarch, or a sheikh?

But interestingly, with affordable space in the capital drying up as the population expands, London's canals are enjoying a renaissance.

Canal living has become increasingly fashionable as house prices escalate; but it isn't for everyone.

As one canal dweller explained, "You have to be very careful to keep your battery charged, to know how much water you have got and where the nearest water point is. And certainly emptying the toilet every week is not everyone's idea of pleasure."

However, it is the sense of community that is particularly valued.

It is also a far cheaper way to live. A 55ft Canal Boat will cost you about£20,000 and require another £2,000 a year to run, license and maintain.

Of course, canal life has now become so popular, there are 3,000 boats chasing only 2,000 moorings. This means moving your boat every 14 days until a permanent spot becomes available, at about £2000 a year in a nice location.

But if you suffer from seasickness, perhaps you would consider the

opportunity to live in a converted public toilet?

London architect Laura Clark has turned a set of public lavatories into a visionary piece of architecture.

Bigger than most London flats, it has its own subterranean garden, and all of the necessities of modern life. Those who were initially sceptical, or even considered the notion somewhat deranged, have since applauded the result.

Just as stables were once the foundation of what are now very desirable residences – central London's mews houses – garages are following in their footsteps.

In Islington, architects have converted rows of little-used garages into high-spec council flats, in a bid to create much needed homes.

Once the haunt of fly-tippers and drug-dealers, the garages have become 15 pleasant one-bedroom flats.

In East London, always a leader in all things fashionably hip, disused shipping containers have earned a new lease of life.

They are being transformed to create shops and restaurants, and more recently into classrooms, office space, sports halls, artist studios and live/work spaces.

It is a low cost and rapid way of building, commended by both the Government and private sectors for the ingenious way it economically recycles tons of rusting metal heading for landfills.

Ever inventive, Ikea have created 'BoKlok' – a groundbreaking scheme that quickly provides blocks of flats and terraced houses.

About 80% of each home is pre-built in module form, with the actual on-site construction taking about a month. The result is cost-effective, with reliable quality control.

Perhaps not as dramatic as having the whole Shard or Gherkin as your home, but probably more stress-free.

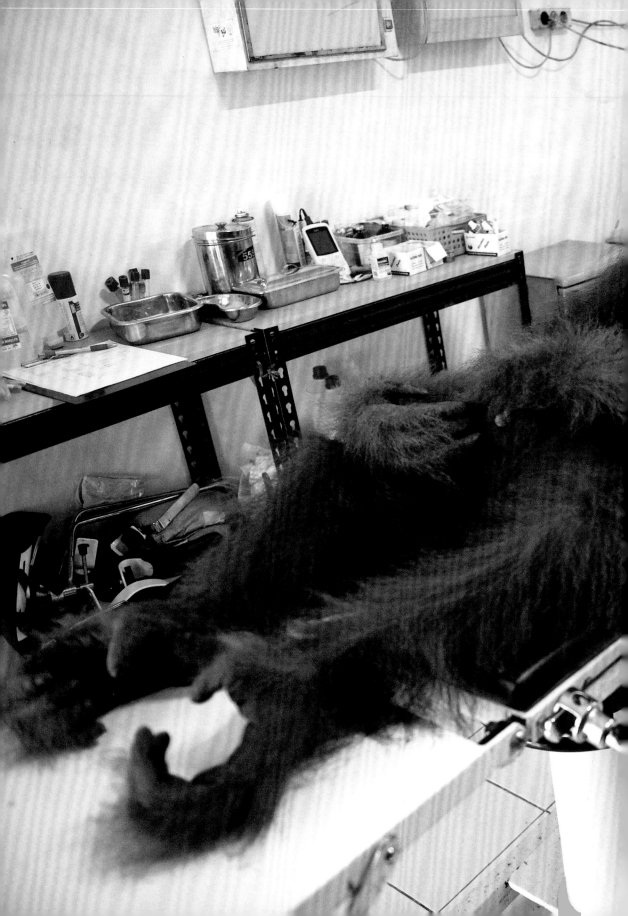

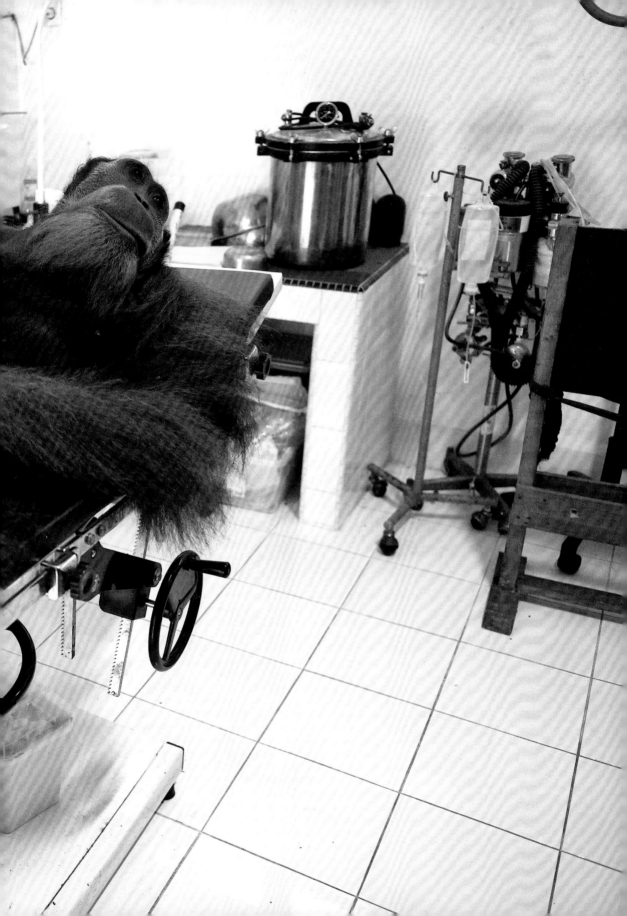

The orangutan gang.

Angelo, a 14-year-old orangutan, is seen here being treated at a medical facility in Indonesia. He had been peppered with hundreds of air gun pellets fired by a gang of very young local tearaways – they found it entertaining to torture poor Angelo by using him for target practice.

It isn't that unusual for gangs of youngsters to be capable of great cruelty. They have been known to egg each other on as they set fire to destitute unfortunates sleeping rough, or to knock to the ground as many elderly people as they can find, to steal their modest belongings.

Disturbingly, they can begin even before turning into teenagers. Scotland Yard has reported a 31 per cent rise in the theft of bikes and mopeds. Older gang members get children to steal them so they can be used for handbag and mobile phone snatches. One two-wheeled team committed 46 offences in 11 days, even targeting several pregnant women.

Children, including girls as young as 10, are being introduced to a life of crime through their involvement with gangs, often being recruited at the school gates. Encouraged by their friends or bullied into joining, the children start imitating older thugs and soon begin to spiral into their grim world.

Established gangs set up junior chapters – the Croydon gang Don't Say Nothing has a youth branch called D2M – Down to Murder.

Doctors have reported a new trend of violence among these pre-teens. A practice named "dinking", a knife stab in the rectum, the groin, buttocks or

thighs is commonplace, probably because the attacker is still too young to thrust higher.

Other countries are also seeing criminals evolving ever earlier. One 10-year-old in New York was caught after robbing an 81-year-old woman and subsequently setting fire to a local store. It was part of an initiation rite to join the notorious Brooklyn Crips. The youngster in question had brought a four-year-old along with him.

In Peru, the youngest ever contract killer was arrested after gunning down three rival gang members and a policeman during a shootout. He was 12 years old.

On the other side of the world, Melbourne police have reported a surge in young scooter and bike thieves. "You have to catch them between eight and 10 years old because by 14 or 15 it's too late and they are stealing cars," they stated.

Problematically, in many gangs around the world, members wanting out are threatened with death if they even consider quitting, giving them no choice but a life as a career criminal.

Horrifically, in the UK over the past four years, police have investigated more than 120 rapes and sexual offences involving child suspects – and many hundreds of children as young as 10 are arrested for violent crimes, drug dealing, carrying firearms and knives. Only a small number are prosecuted. In Northamptonshire, two 12-year-olds were arrested for manslaughter but never charged. In North Wales a 10-year-old was formally prosecuted for sexual assault and received a reprimand.

A Children's Commissioner's enquiry reported that "girls feel that rape is an inevitable part of growing up in their neighbourhood, and there's no point in telling anybody because nothing will change".

One of the most alarming cases involved a 12-year-old boy who regularly abused his little sister after he and his friends had become addicted to hardcore pornography online. He was given a three-year rehabilitation order. As the judge at his hearing told his parents: "The internet is not a benign babysitter."

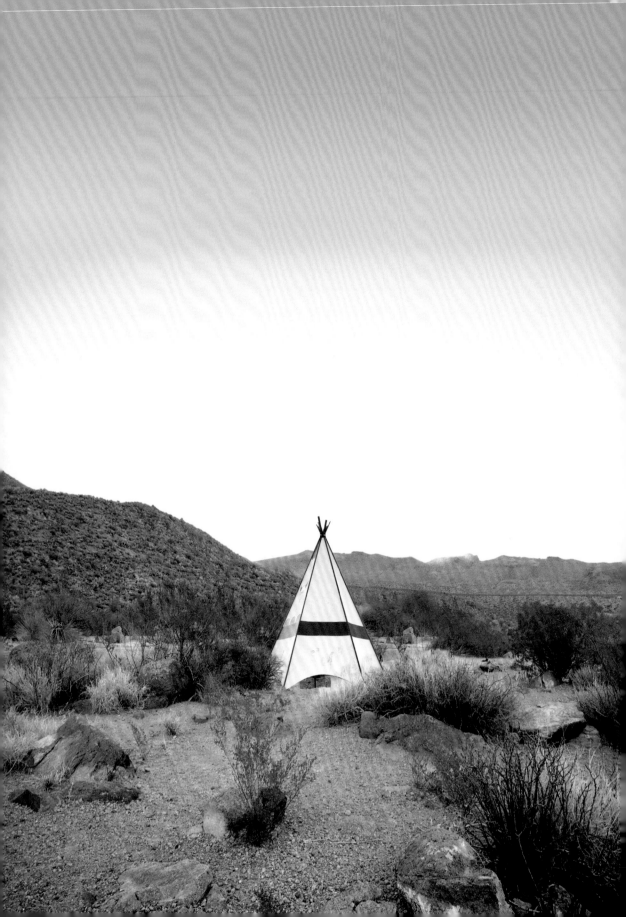

Teepee for a weewee.

If you are ever on a road trip around Texas, and desperate for a toilet, help is at hand.

This teepee lavatory can be found just outside the Big Bend national park, near the Rio Grande which divides the US and Mexico.

Back home in London, how do we explain the disappearance of the familiar Public Conveniences over recent decades?

Surely people still need them as much as ever.

With millions more living here now, at any time of the day or night there will be a vast number of men and women who are feverishly trying to find a toilet.

Furthermore, as a result of our status as the world's favourite tourist destination, we are probably peeing-off many tourists to the capital, also frantically looking for the same thing.

Paris might have fewer visitors, but it provides many more such facilities on its streets – and thoughtfully they are free.

Since 1960, London's public toilet provision has fallen by over 75%.

Many reasons are cited for these closures, most reliably a lack of funding. For local councils, it costs too much to keep them manned, clean and functioning.

Unfortunately there is also the matter of unsavoury behaviour taking place in such premises at night – police make plain the fact that they became venues for drug-taking and amorous meet-ups.

Others point out that the vast majority of them were underground, and so of no help to the disabled.

Councils are under no legal obligation to provide toilets, so instead they have simply been abandoning them or selling them off, and failing to provide replacements.

Why they haven't followed the example of Paris, with its automated cubicles seen on most main streets is no mystery – we can't afford it of course.

Instead, some councils have at least chosen to pay a retainer to local businesses, in return for them alerting the public that they are welcome to use

their own facilities.

So what do you do, or where do you go, if there is nowhere to…go?

Most high street chains are fairly ambivalent about the public using their loos; McDonalds has long since been seen as the unofficial public toilet provider.

"Strictly speaking, our lavatories are for McDonalds' customers only," a spokeswoman says.

"However, the restaurant manager is unlikely to take exception to potential customers using the toilet unless it's felt that the use of the facilities by non-customers is hindering paying customers at any given time."

KFC are less relaxed at the thought of toilet users not making a full purchase in exchange for the use of their facilities, and Starbucks also likes to ensure that their toilets are for customers only.

The Pret a Manger chain, which seems to be more evenly distributed across the capital than its competitors, doesn't have public toilets except in its large branches.

But again, what are you to do if you are truly desperate, and simply cannot contain yourself for another minute or so?

It seems unclear legally speaking whether urinating in public is an offence, and the general rule seems to be that you are ok as long as you are discreet, and out of sight.

Hopefully you wouldn't be charged with sexually exposing yourself, or with disorderly behaviour.

And there is good news for some.

An ancient law, which has never been repealed, is the right of a pregnant woman to urinate in a policeman's helmet.

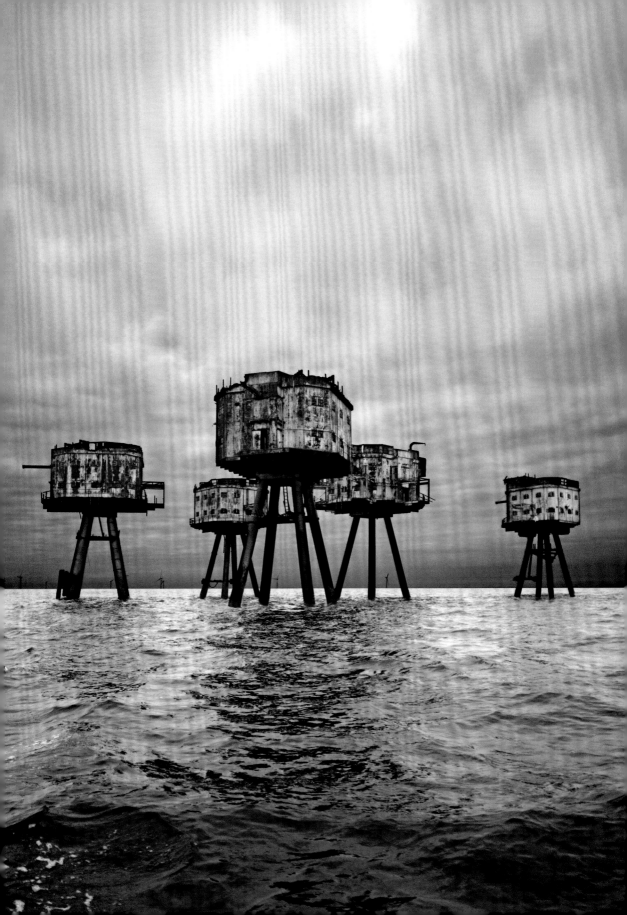

Property gems on the Thames.

Do you like sea views? These abandoned forts in the Thames Estuary offer magnificent 360 degree vistas. The structures were built during World War II, when London faced heavy attacks from the Luftwaffe.

The forts were manned by 120 men over seven floors, and equipped with Bofors cannons, and a radar early-warning capability.

They were decommissioned in the Fifties, and then somehow forgotten. Today, they offer an attractive conversion opportunity for imaginative families who love sea air, and seclusion.

They would certainly beat some other unorthodox homes in terms of square meterage. These include a garage in Stoke Newington that was offered at£359,950. Somewhat dilapidated and rusty, it was marketed as ready to be transformed into a bedsit, and presented as a bargain compared to other properties in the area.

A property in Forest Hill, requiring less of a makeover, was priced at£280,000, and described as a 'bright and airy one bedroom detached house, with a front and rear terrace'. However on inspection, it appeared to be little more than a spruced-up shed in someone's garden.

More bizarrely, advertised on the Spareroom website was a room available at £480 a month. In fact, this too was a shed, but actually built inside the lounge of a house in Bethnal Green.

A landlord in Hendon was fined for renting an attic for £420 a month –

but the tenants could only reach it by crawling up the stairs, because the head height was too low for anyone but a small child.

Incredibly, in Kingston renters have been asked for £400 a month for a single bed placed inside a shared kitchen.

If you don't suffer from claustrophobia, or have a great number of possessions, a property in Haringey might suit you. It became celebrated as London's narrowest house. At only 83 inches wide, the house was built on a pathway between two terraced homes, and includes a reception room, kitchen, bathroom, two bedrooms and even a loft.

It lost its status as London's slenderest dwelling to a rival in Shepherd's Bush, just 72 inches wide, and offered at £500,000. However, this is grandly spacious compared to the world's thinnest house, found in Warsaw, Poland.

Forty-eight inches wide at its maximum, the home inhabits what could only have been an alleyway before. Even the architect accepted that living in the house 'requires a sense of humour'.

For those who have no great love of natural light, or who have a fascination with the subterranean, then a modernist house in Hampstead is ideal.

Including its 3 bedrooms, virtually the entire property is below ground.

It offers a fully equipped gym and a plush cinema room, possibly because potential owners would clearly prefer burrowing inside, quietly hibernating, rather than dealing with the wide-open expanses of the Heath.

In Hinkley, Leicestershire, a home was designed to replicate the interior of the Star Trek Voyager spaceship, complete with LED lighting and intergalactic sound effects. The decor was not popular with the owner's wife, so it was soon on the market, seeking someone who wished to live long and prosper.

A bewildering house in Tokyo has been designed as an entirely see-through building, with ground to roof glass walls, floors and ceilings. Its bedrooms, lounge and kitchen are all totally visible to passers by.

In case you were curious, the bathrooms and toilet are on full display as well. All very naturist, but probably not for London. We are simply too nosy, and besides that, somewhat protective of our privacy.

Dognapping.

There has been a 20 per cent rise in canine thefts in the past two years – with pets often being stolen for the black market in illegal dog fighting. Staffordshire bull terriers and Rottweilers are frequently targeted as they can be easily trained to become fearsomely aggressive combatants.

Recently, the most stolen breed has been the cocker spaniel, having leapt in popularity because of Lupo, the favourite pet of the Duke and Duchess of Cambridge. Other dogs regularly dognapped include Jack Russells and Chihuahuas, which are considered desirable all across Europe and are easily sold. Often, stolen pets will be bought by foreign laboratories for animal testing; others are kept for profitable breeding.

It used to be simply an opportunistic crime – a dog was just snatched off the street, attracted by a juicy bone into the back of a van.

Today, dog stealing is described by experts as "more about organised criminals carefully selecting places like kennels, where there can be multiple thefts of valuable dogs, sold off cheaper than going through a breeder".

In England approximately 50,000 dogs are stolen each year.

Dognapping ransoms have escalated to an average demand of £500, rising to £2,000, to get your pet back.

Police are concerned that a victim in London paid £20,000 for the return of a cherished dog and fear that this kind of sum will encourage more specialist thieves. They track valuable rare breeds or watch for well-off families with deep

emotional ties to their pet.

Britain's first recorded dognapping occurred in 1965 – a racing greyhound named Hi Joe, valued even then at over £5,000, was stolen from his London kennels.

The thieves had seen the dog win his last six races and hoped to take Joe to Scotland to compete – but were caught after a tip-off.

Worryingly, there has also been a recent boom in internet frauds, with people falling into the trap of buying non-existent dogs online. Scammers post images of adorable puppies on a number of pet sites.

They convincingly assure potential customers that the pedigree pups have been "fully vaccinated and ready for a loving home".

Naturally, a wire transfer payment is required before the puppy from a new litter can be delivered. The instant the cash arrives the scammer's online account closes and the buyer finds himself waiting for a dog that will never arrive.

Criminals have also begun to respond to genuine advertisements placed online offering puppies for sale – and have visited the breeder, posing as purchasers coming to view the dogs before returning later to steal them.

In a more positive use of the web, when a Liverpool pug owner received a phone call demanding £1,000 to return her stolen pet, she posted details of the crime widely across Facebook.

The thieves returned the pug safely – but insisted that first the story be removed from Facebook before it attracted too much attention to their scheme.

A more frustrating theft recently occurred in Maidstone. A family pet had disappeared and the owners placed a number of reward posters across the town.

After receiving a ransom call from the thieves they met for the exchange and paid £500 for the return of the dog.

A few days later the dog was stolen again by the same crooks and the family were forced to pay the full ransom for a second time.

Sadly, only about 5 per cent of dognappers in the UK are caught and prosecuted.

Is your wife a nag?

Let me explain instantly that husbands can make equally fine nags.

But for guidance I turn, as I am sure you do, to the teachings of the bible:

"Better to live in a desert than with a quarrelsome and nagging wife." (Proverbs 21:19)

Nag is a word derived, rather graphically, from Old Norse 'gnaga', to bite or gnaw.

Fortunately, there is a plethora of advice for victims of nagging (male and female) from professional counsellors.

But how can you tell if you have become a nag?

According to Michele Werner-Davis, a leading relationship therapist, there are a number of key signs:

Your partner becomes increasingly defensive each time you ask for something.

The things that bother you tend to grow in scope – you're more bothered by more things, more often.

Your irritation is contagious – the more irritated you get, the more irritated your partner gets.

The weaknesses in the relationship, such as things your partner isn't doing, become the focus – rather than appreciating the strengths in your relationship.

You are increasingly frustrated because you're not getting through to your partner, despite asking again and again.

This leads to the most obvious signal that you tend to nag: you've said the same thing five different ways, five different times, and yet you keep on going.

For some, being nagged is little more than an irritation. However, new research has revealed that the arguments and tensions created may have a much more detrimental effect than expected.

It was found that having a particularly demanding partner is linked to hundreds of deaths a year.

Men subjected to relentless nagging and criticism from their partner are 2.5 times as likely to die far younger than their counterparts in less stressful relationships.

However women seem to be somewhat immune to nagging, as the study revealed that it has little effect on female death rates.

CNN's Jayson Santos offers some candid, indeed brutal advice to the nagged males of the world. The simple reality, he suggests, is that if your wife is constantly nagging you, it means that she is no longer attracted to you.

He insists that 'a mentally healthy woman resents her partner if she is able to dominate him through her nagging.'

To fix this, he advises making her 'ultra-attracted to you' through a series of important steps.

"Attraction is the primal and basic force in all relationships," he notes.

"If your wife is controlling and nagging you then you have an attraction problem.

"Remember that she will consider a man's faults and infirmities as 'cute' if she is very attracted to him. That is why people says 'love is blind'.

"The reality is, it is attraction that makes her overlook your faults.

"Learn the right attitude, skills and behaviour that you need to become an attractive man for your wife. It all boils down in being a better person each and every day and staying there no matter what your wife throws at you."

If you are a man you may have found Jayson's helpful insight deeply profound. If you are a woman, you will recognise it as misogynist nonsense.

I prefer the French view on nagging and life in general: everything in moderation, including moderation.

And despite the advice of the bible, perhaps a quarrelsome life may be better than the alternative suggested in Proverbs.

Remember, almost a third of our population are now living on their own, part of what is known as 'Lonely Britain'.

Do you believe in coincidence?

In 1990, a 15-year-old student from Argoed High School in Flintshire, Wales sat for his GCSE examinations. His name was Bond... James Bond, his paper reference number was 007, and the exam invigilator was a Mr. Goldfinger.

Neville and Erskine Ebbin both died aged just 17, in a road accident with a taxi. However, they were killed a year apart, while each was riding the same moped. Bewilderingly, both brothers were killed by the same taxi, which was being driven by the same driver, and it was carrying the same passenger.

When Henry Ziegland dumped his girlfriend, it drove her to commit suicide. Her brother wanted revenge, shot Ziegland, and then quickly took his own life. However, Ziegland survived the shooting, the bullet grazing his face and going on to lodge in a nearby tree.

A few years later, when he was trying to cut the tree down, Ziegland used a little dynamite to speed the process. The explosion caused the bullet to fly straight to his head, killing him instantly.

Desperate to find his long-lost daughter Lisa, carpenter Michael Dick travelled from Bow, East London, to Sudbury, Suffolk, where he had heard a rumour that she was living. The local Suffolk paper ran the story of the father's search, with a new photograph of him and his two other daughters.

Not only did Lisa, 31, spot her dad, she realised she was in the picture too. She explained that she had been in the exact spot where the photo was taken, about a minute earlier, and could be seen walking past in the background.

In 1937 street sweeper Joseph Figlock was cleaning an alley in Detroit when a baby boy fell from a fourth-storey window and landed on his shoulders. It broke the infant's fall, saving his life.

A year later the same tot fell again – and Figlock was passing below.

He was looking up to where the baby had fallen earlier, and suddenly found himself able to save him a second time.

If you like strange mysteries, you will find many at sea. In 1660 when a ship sank off Dover, the only survivor was called Hugh Williams.

In 1767 another ship sank in exactly the same spot and the sole survivor was called... Hugh Williams.

In 1820 a ship capsized on the Thames and the only man left alive was... Hugh Williams.

And in 1940 a German mine blew up a ship leaving two survivors – a man and his nephew… both called Hugh Williams.

In 2002, seventy-year-old twin brothers died within hours of one another after separate accidents on the same road.

The first of the twins died when he was hit by a lorry while riding his bike, just 1.5km from the spot where his brother was killed hours later.

"This is a historic coincidence. Although the road is a busy one, accidents don't occur every day," explained the police. In fact, the twin brothers Jim Lewis and Jim Springer had been separated at birth, and adopted by different families.

Unknown to each other, both families named their boy James.

Both sons grew up not knowing of their twin, yet both had sought police and security training, both had abilities in mechanical drawing and carpentry, and each had married women named Linda.

Both had sons, one of whom was named James Alan and the other named James Allan.

The twin brothers also divorced their wives and married other women, both named Betty. And they both owned dogs which they named Toy.

Coincidences? Or some mischievous power playing with his toys?

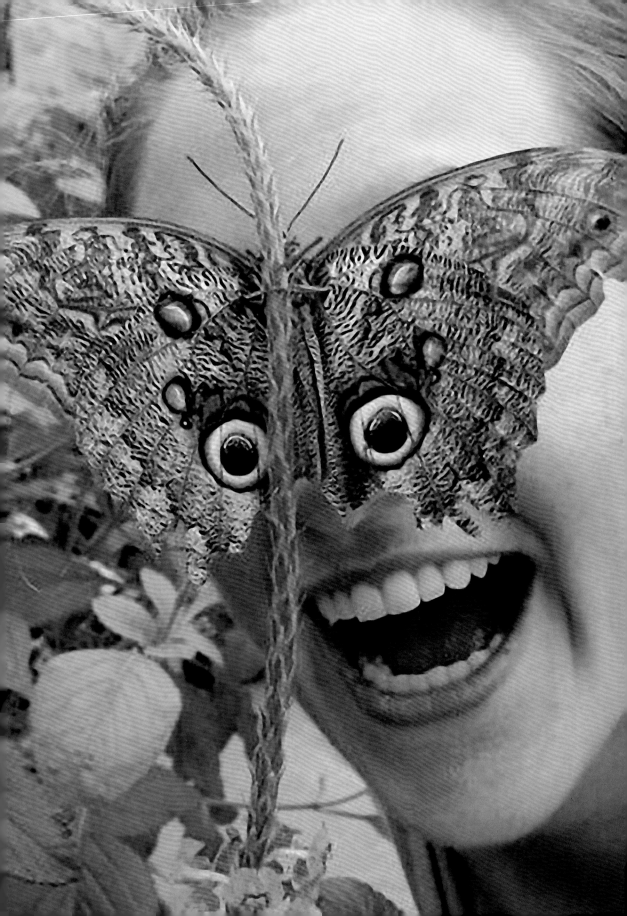

Are you a social butterfly?

Do you live to party, dressed in the newest fashions, flitting from one event to another, with a brow unfurrowed by a care or a purpose?

Like a butterfly momentarily landing on flower after flower, the expression portrays someone vivaciously extrovert, entertaining company, and always armed with the latest amusing gossip, ready to share at all the right places.

A 'party animal', however, could be seen as a more pejorative description, suggesting you are uninhibited, wildly exuberant, drinking freely, staying up late, heartily sharing a good time.

A party wouldn't be a party without a sprinkling of both kinds of guests. Of course it is unlikely that most of us would want, or could afford, to be as flamboyant as Sultan Haji of Brunei for his 50th birthday celebration.

Held in 1996 he flew in Michael Jackson to perform for his 10,000 guests, at a cost of $16 million, with the party in total costing $27 million.

Steel tycoon Lakshmi Mittal's net worth is over $16 billion, so when the time came for his daughter, Vanisha, to get married, the party budget was never high on the agenda.

The invitations for each guest were made of silver and filled over 20 pages.

Everyone was flown to Paris and accommodated in 5 star hotels, with the ceremony held in the Palace of Versailles.

The wine bill alone was over $1.5 million, and later that night the Eiffel Tower was booked in order to host a fireworks spectacular.

Truman Capote always predicted that one day when he was wealthy and celebrated, he would throw a party that would be remembered forever.

When his book *In Cold Blood* became a great success, he felt the time had come.

It was to be The Black and White Ball, with society's elite asked to wear only black and white, along with black and white masks.

What did they eat? Sausage, scrambled eggs, spaghetti, meatballs, chicken hash and chocolate.

The party was described as the last great moment in New York City's social history.

Frank Sinatra didn't leave until 3 am.

Hip-hop star P Diddy is an expert at splashy party-throwing, and offers a helpful guide here to would-be hosts:

"The top five ingredients for the perfect party are the people, the music, the amenities, the food and drink, and the lighting. It sounds easy enough, but it really isn't.

"You need to keep playing around with those elements to get them just right. For a great vibe you need to pay attention to every detail.

"I've thrown parties where there has been everyone from Presidents, to Madonna, to David Beckham, to my relatives – even people from my hood.

"The best parties go on forever, because you don't want them to stop. I've had times when I've started partying in New York and taken a jet to Miami to finish off, or started in Paris and then flown to London, or started in Ibiza and then jetted off to Sardinia.

"Normally I give people only about four or five days' notice to weed out potential gate-crashers.

"If your party's going through a slow patch, one of the best things to do is propose a toast – it peps people up instantly. Sometimes you just have to let everyone know how fortunate they all are.

"I send my guests away with a goodie bag – the best ones have diamond watches. I also like to give away jewellery if possible."

All very lovely, but really not for me. I fear that my kind of party animal is a sloth.

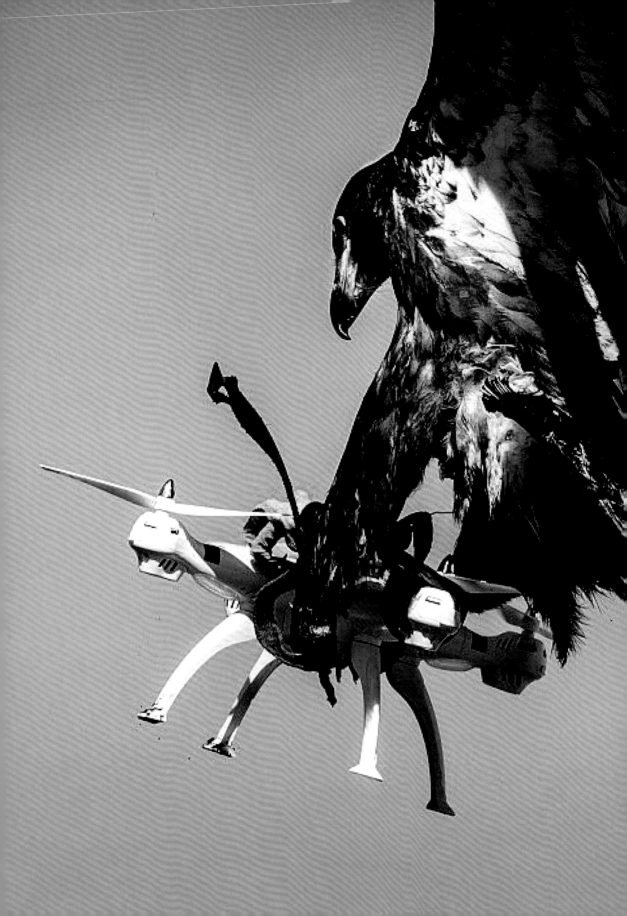

Death of a drone.

Drones have become an accepted part of life these days.

The idea of being watched over by a flying eyeball is little different to being constantly monitored by CCTV.

They come in numerous shapes and sizes, and are used by the military for a variety of reconnaissance purposes.

Routinely, they hover high above places of interest to provide crystal sharp real-time images back to their minders.

The 'pilots' sit at bases thousands of miles away, scanning their screens, and operating the drone. Of course the larger drones are weaponised, carrying powerful Hellfire missiles that strike with pinpoint accuracy.

But however precise the attack, there are often innocents killed in 'collateral damage', a phrase that sticks in the craw of many observers.

However, to advocates, drones save lives, terrorising the terrorists who know that they may constantly be in the crosshairs of an invisible hovering weapon.

Furthermore, the military don't have to face the risks of putting their soldiers on the ground.

Deployed by many nations – initially the U.S., U.K., Iran, and Israel – other countries have developed their own drone air force, including China, Pakistan and Russia.

Is this the first step towards of a future of automated robot armies, equipped with some level of artificial intelligence, sent into conflict zones and

battlefields? Early steps are already being seen. The U.S. Army wants robot medics to be utilised to carry wounded soldiers to safety.

Unarmed and unafraid, they reduce the perils for doctors courageous enough to have gone forward to rescue injured comrades under fire.

Already being tested by the U.S. is the Black Knight Transformer, an unmanned ambulance that can fly like a quadcopter and drive like a truck.

Iran's new Nazir robot cars carry two missiles, and remote drivers can see what the Nazir is looking at, from miles away.

Recently, Iranian generals promised that they have created functioning robot soldiers, but nobody has seen evidence.

The U.S. has been testing armed robots laden with heavy machine guns and rockets for a number of years, and expect them to replace a sizeable proportion of combat soldiers before mid-century.

U.S. Marines are using a GuardBot, a rolling ant-like device that looks like it belongs in a sci-fi alien movie.

The bot is amphibious and can scout ahead in rivers or on marshy terrain, able to see in many directions at once.

It can use a laser spectroscope to detect chemicals in explosives, making it far safer than using bomb disposal specialists to approach a possible danger.

The U.S. Atlas Robot is already in use, able to crawl through rugged terrain; its purpose is to imitate human rescuers in disasters and emergencies.

Alongside it, the Robo-Roach mimics the way cockroaches manoeuvre, squeezing through teeny cracks and narrow crevices.

A report recently shown on the Russian state-owned RT news channel was entitled 'Military cyborg biker presented to Putin'.

However, all it demonstrated was a robotic figure, wearing what looked like a Daft Punk helmet, moving slowly around a small track in a 4-wheel vehicle.

Perhaps this was a piece of disinformation – and in reality Russia has a stock of highly sophisticated robotic Spetsnaz warriors, ready to strike with advanced laser weaponry at anyone foolish enough to poke the bear.

Let's hope we never find out.

An unwanted baby.

As you know, newborn babies are not always greeted with enthusiasm by their slightly older brothers and sisters.

When the spotlight, and the billing and cooing, is transferred to the new arrival, it takes a resolute young child not to be troubled by a sense of betrayal and abandonment.

However, sibling rivalries are soon forgotten, and strong bonds take shape. But not in all cases; sometimes the bitterest feuds between children last a lifetime.

The battle for supremacy between sports giants Adidas and Puma has been hard-fought for decades.

But the commercial war is more about the companies' founders – two brothers who disliked each other intensely, and then decided to form fiercely competing businesses.

The two global brands were founded 60 years ago, after successful shoemaker brothers Adi and Rudi Dassler had a virulent falling out.

The siblings formed rival manufacturing plants on opposite sides of Austria's River Aurach, which runs through the centre of their home town, Herzogenaurach.

"The split between the Dassler brothers was to Herzogenaurach what the building of the Berlin Wall was for the German capital," says local journalist Rolf-Herbert Peters, with the hostility between Adidas and Puma remaining obvious even to outsiders visiting the town.

"The enmity has divided the population, determining which pubs the town's 23,000 citizens drank in, the butchers they frequented, who cuts their gravestone, and which football team they support."

How the intense antagonism between the brothers started is a much debated subject.

A widely accepted explanation is that Rudi, who was supposedly the better-looking brother, had an affair with Adi's wife – though many point out the feud preceded this.

But any number of other theories abound – who was the more enthusiastic

Nazi (both joined the party in 1933), or who could claim the invention of the screw-in soccer boot studs that helped Germany's national team secure its World Cup final victory over Hungary in 1954 on a soaking pitch in Bern.

"There was a time when you'd have risked the wrath of colleagues and family if, as an employee of one company, you married the employee of the other," says Klaus-Peter Gäbelein of the local Heritage Association.

"Even religion and politics were part of the heady mix. Puma was seen as Catholic and politically conservative, Adidas as Protestant and Social Democratic."

The sibling rivalry between two screen goddesses of Hollywood's Golden Era, Joan Fontaine and Olivia de Havilland, was so deeply ingrained in movieland legend it might as well have been engraved on the Walk of Fame.

Born only 15 months apart, these sisters followed the same career path, competed for the same film parts, and even dated the same men.

Olivia de Havilland was the first to become an actress. When Fontaine tried to follow her lead, their mother, who had always openly favoured Olivia, refused to let her use the family name professionally.

As *Life* magazine put it in a profile on the sisters titled 'Sister Act': "There is no danger that sisterly affection will break suddenly upon them, and dampen the rivalry and the girls' careers."

In 1942 the sisters went head to head in the race for Best Actress at the Academy Awards – De Havilland was nominated for *Hold Back the Dawn* and Fontaine for *Suspicion*.

Despite the open animosity between the two, Hollywood insiders who were awaiting a violent outburst from the losing star were surprised when, once the Oscar went to Joan, Olivia seized her sister's hand and cried, 'We've got it!'

One can't imagine the Dassler brothers being quite as gracious to one another.

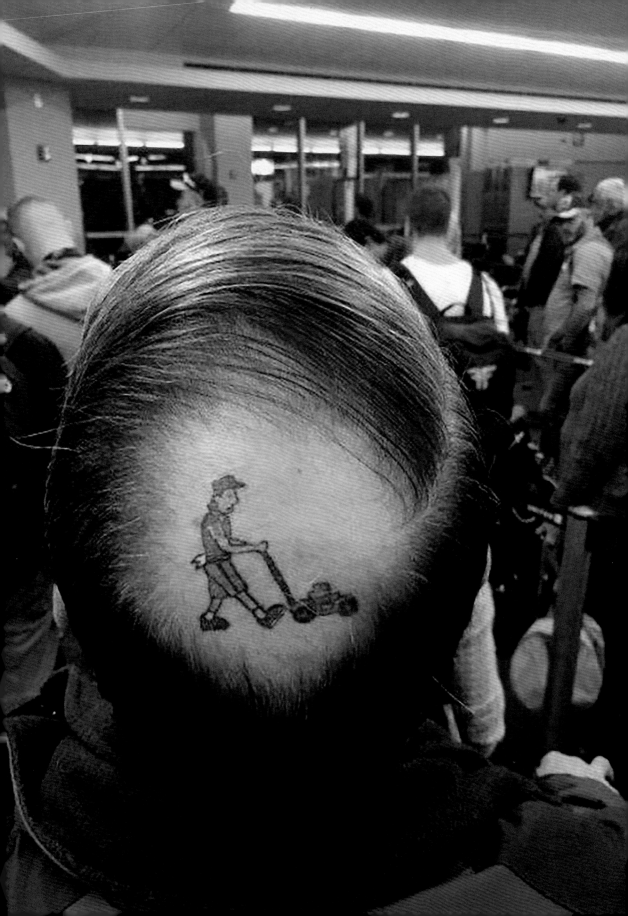

No hair. Don't care.

A truly dreadful fashion trend is now upon us – the man bun.

But while many may think that this new hairstyle adopted by edgy young men is simply idiotic, there are others who probably look at those buns in envy.

Baldness deeply concerns millions of men, for some from as early as in their twenties.

Despite the multitude of products on offer that promise to restore their locks, most continue to lose hair nonetheless.

Balding is primarily a hereditary condition but there are other factors that can exacerbate the problem.

Stress is high up on the list, according to trichologists.

A bad diet also doesn't help – the lack of important nutrients can lead to fragile hair.

The good news is that British men tend to go bald later in life than their European counterparts.

However according to a recent survey, we agonise about hair loss more, and are frequently too self-conscious to do anything much about it.

German men are less fussy about accepting that the problem needs dealing with professionally, happy to routinely use implants, or weaving techniques, even a full hairpiece.

Depressingly, 75% of men who have started losing their hair suffer from self-esteem and insecurity worries as a direct result of hair loss.

Apparently it makes them feel old, and less attractive; in fact, ending up with a smooth, shiny dome is the most dreaded part of ageing for most men.

The report makes clear that they consider failing to perform in the bedroom, losing their teeth, or going half deaf, virtually on a par with going bald.

One sufferer noted that "Men who lose hair are expected to adopt a laissez-faire attitude and take insults with good humour.

"The pressure this causes can have a mounting effect on men's self-confidence, with knock-on effects on physical and mental well-being."

But there are some happy advantages to going bald, besides the time and money you save on tending and grooming your hair.

A study into prostrate cancer showed that men who start to lose their hair at a young age have half the risk of falling victim to the condition than men with a full head of hair.

The report pointed out that if you are full to the brim with testosterone, which makes you exceptionally manly, it can cause your hair to fall out – but it does slow the development of tumours in your body.

It also helps your metabolism stay high, keeping you in shape, maintaining a healthy weight and increased muscle growth.

You will have less fat in the face, to contribute to a more chiselled look that women find attractive.

Another study asked respondents of both sexes to look at photos of men with full hair, and give their opinion of the same men with their hair digitally removed.

These versions of the men were found to look stronger, and more assertive.

A bald scalp is associated with tougher professions – soldiers, policemen, firefighters.

Baldness also gives you an advantage in business dealings, particularly if you celebrate your baldness by cutting your remaining hair very short, or shaving it off altogether.

Experts believe this gives you an aura of power.

Have you noticed how bald men don't appear to age? As other men go grey, bald men look much the same for decades, rather as Bruce Willis has.

Additionally, Steve Jobs made being bald seem very cool.

It's going to be a bumpy ride.

Are you deeply ambitious?

Whether you are born with several silver spoons in your mouth, or have to claw your way up from the depths of poverty, many pitfalls lie in wait on the path to the top.

The greater the success you seek, the bigger the obstacles to overcome.

"If you're going through hell, keep going." This sentiment, expressed by Winston Churchill, seems to have been the touchstone for many of the world's greatest achievers.

What separates the exceptionally successful from the rest of us is their fortitude at coping with failure, and their commitment to resolutely keep trying.

You probably know of Harland David Sanders as Colonel Sanders of Kentucky Fried Chicken. His secret chicken recipe was rejected 1,009 times before a restaurant accepted it.

Charles Darwin gave up a medical career, much to the dismay of his father who thought him lazy and too dreamy. Darwin himself wrote that he was viewed by his tutors as "below the common standard of intellect".

Isaac Newton was considered such a poor student it was thought best to let him simply run the family farm.

He was so inefficient at the job an uncle had to take over. Newton was just packed off to Cambridge, where he finally blossomed into one of the greatest scholars of all time.

Thomas Edison similarly grew up being told repeatedly that he was "too stupid to learn anything". He was subsequently fired from two jobs for not being productive enough.

Edison made more than 1,000 unsuccessful attempts at creating the light bulb, before one finally worked.

Akio Morita invented a rice cooker that sadly burned rice rather than cooked it. He only managed to sell 100 machines, most of which were returned by dissatisfied customers.

This setback didn't stop him from starting a new company that did

somewhat better – Sony.

Soichiro Honda was turned down by Toyota after being interviewed for an engineer's post. He started making scooters at home while waiting to find a job, until his neighbours encouraged him to start selling the mopeds as a business.

Abraham Lincoln joined the infantry as a youth, went to war as a captain, and returned as a private.

He opened one failed business after another, and was defeated in numerous attempts to seek public office.

Steven Spielberg was rejected from the University of Southern California School of Theatre, Film and Television three times.

He got into another college but dropped out in order to try directing.

He returned to the school in 2002 to finally complete the course, and earn his BA.

Growing up very poor doesn't appear to have been a handicap to many of the world's current billionaires; to some it was the spur that drove them onwards, long after they had become millionaires many times over.

Ralph Lauren worked at a clothing retailer as a minor clerk after leaving the army. He had the notion that men's ties could be brighter and wider, and by 1967 he had sold £300,000 of his designs, and started the Polo brand.

Lauren is now worth £10 billion.

François Pinault is even wealthier and owns many iconic fashion labels including Gucci, Yves St Laurent, Alexander McQueen and Stella McCartney, as well as Christie's auction house. He had to quit school at 15 because he was bullied mercilessly for being so penniless.

Let Winston Churchill have the last word: "Success is walking from failure to failure with no loss of enthusiasm."

Do brainy people worry more?

The problem with being brightly intelligent, and having a vivid imagination, is that you worry twice as much. You fret with anxiety about bad things you sense could happen, before they actually take place.

And then, if something you dread does indeed materialise, in effect you have to suffer that anguish all over again.

Remarkably, 86% of us describe ourselves as worriers – concerned about issues like relationships, money and work, alongside little fears such as missing the train, or getting a parking ticket. Apparently Britons spend almost 5 years of their life worrying – an average of 1 hour 50 minutes a day.

There are some specific torments that plague the majority of us.

Reliably leading the field are the worries about getting old, our future financial stability, the amount of debt we are piling up. For some it will be the need to diet, or misgivings about our health and fitness.

According to the latest research, it seems that the group least happy, with the lowest levels of life satisfaction and the highest levels of worry, are the middle-aged. Thankfully, the study also shows that life gets better once you make it through those years.

For people that reach 60, the trend begins to reverse, with 65–79s reporting the highest levels of personal well-being.

Even those over the age of 90 are happier than those aged 40–59.

At the other end of the scale, people under 30 worry more about their

popularity than getting on the property ladder.

But there are also many positives to being a worrier.

Though it often signals a lack of confidence or control, worriers tend to snap to attention when situations call for thought, planning and action.

Surprisingly, last year a team of researchers found that depressed people who suffer from anxiety have a longer life expectancy than those who worry less.

The study revealed that "worrying may be good for you. It is possible that more verbally intelligent individuals are able to consider past and future events in greater detail, leading to more intense rumination and disquiet."

Experts suggest that you should note everything worrying you down on paper.

According to a recent report, making a written list of your problems can reduce the burden of apprehension you feel.

"It's as if you are emptying the problematic thoughts out of your mind," the finding concluded. The old adage that ignorance is bliss conversely implies that higher intelligence increases levels of distress and uneasiness.

This view has been given some scientific backing; researchers found that students who expressed more worry than their peers also scored higher on IQ tests. A worried mind searches, seeking to examine multiple angles of a problem.

It is certainly the case that lying awake in bed at night unleashes your inner worrier, leaving you more overwhelmed by negative thoughts.

Those swirling concerns routinely create the turmoil that keep so many of us tossing and turning–desperate to pleasantly dream the night away, and wake refreshed by a decent night's sleep.

But some good news. Happily, and in moderation, eating confectionery can soothe distress.

A research study found that participants who ate some dark chocolate each day for two weeks reduced their stress hormones.

Celebrate now with a family-size carton of Maltesers, and some Cadbury Mini-Rolls.

Growing old is not for sissies.

As her pronouncement makes clear, Hollywood icon Bette Davis viewed the reality of ageing without sentimentality.

Growing old may indeed be better than the alternative – but for her that didn't much lessen the burdens of deterioration.

Some elderly people remain fit, mobile and alert – but for many the decline is a harrowing prospect; loss of faculties, frailty and pain, a body that is cruelly wearing out. Also proving troublesome is having to cope with the speed the world now changes; advances in technology offer a dizzying array of new ways to communicate, and access to a far wider variety of entertainment.

But for those ready to embrace it, the internet is transforming the lives of older people.

Advanced Style is a fast-growing fashion blog that showcases inspiring men and women in their twilight years.

Photographer Ari Seth Cohen roams the streets of New York looking for elderly subjects who live life to the fullest, without letting the drawbacks of ageing – the loss of loved ones, retirement, loneliness, discomfort – hold them back in the slightest. *Vogue* magazine referred to the blog as a 'sociological treatise on ageing and identity'.

With an eclectic cast of artists, designers, writers, fashion buyers, musicians, all over 70, it demonstrates that you don't need to adopt slippers and a dressing gown when you are no longer lithe and supple.

Brightly coloured hair in blues, greens, and pinks, spectacular costume jewellery, exuberant sunglasses and unconventional fashions aren't merely saved for special occasions – instead they should be worn just to pop out for some milk.

One of Advanced Style's muses Ilona Royce Smithkin makes her false eyelashes from her own flame-coloured hair.

She says, 'Your body is your best friend in the entire world. I think people expect too much of themselves, and that's not happy-making. In trying to be perfect you miss half of your life.'

This is clearly the belief of the protagonists on Channel 5's show *OAPs Behaving Badly*, taking their pensions and winter fuel allowances to set up new lives in Tenerife. They sunbathe all day and party all night, putting the younger crowd to shame. Their nightclub is fondly known as 'God's Waiting Room', for obvious reasons.

Club managers complain that their bouncers are now having to control misbehaving elderly clientele rather than unruly younger customers. Considering the number of tequila shots older clients routinely sink, and their freedom from inhibitions, it seems Club 18–30 can't compete with Club 68–80.

Their general code is 'You've got to party till you drop' – and they mean it quite literally.

This world of feckless pensioners is part of a major demographic shift across the world. By 2050 one in five people on the planet will by over 60, but in the developed world this proportion will be closer to one in three.

Simply, many of us now live longer due to better nutrition, and more advanced healthcare.

As populations grow older, so too does the number of people suffering from Alzheimer's and Dementia; by 2050, there will by over 115 million people dealing with these conditions. But as memories fade, sufferers often regress back into the world of childhood.

So hopefully, we can anticipate a boom in the 'party till you drop' culture, enjoyed in God's Waiting Rooms across the globe.

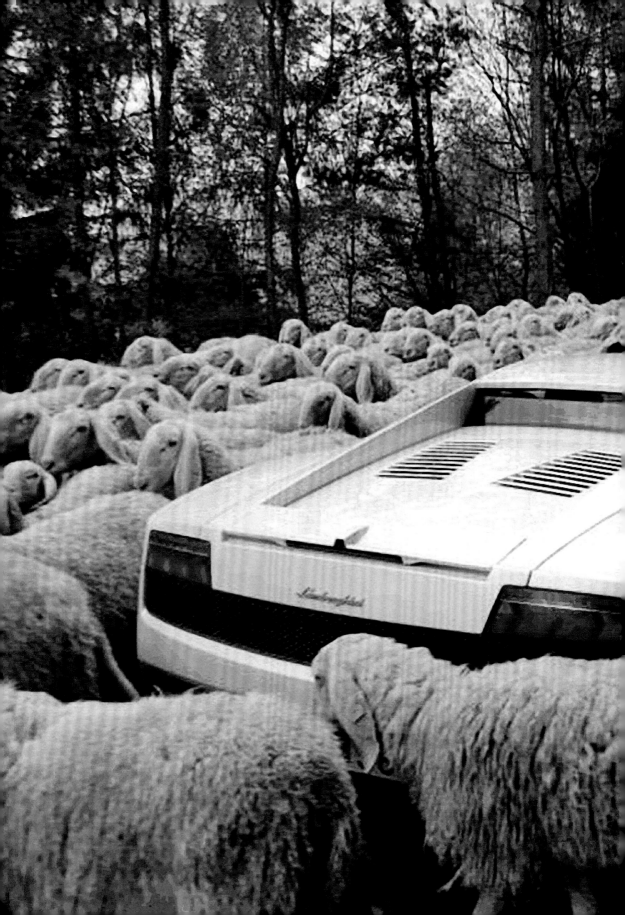

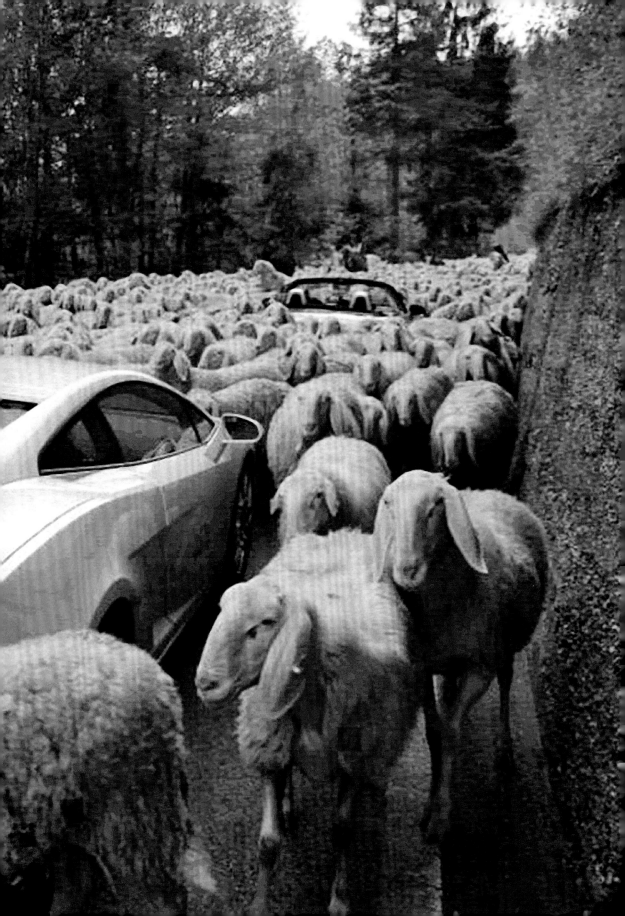

The silence of the Lamborghinis.

What use is a £250,000 supercar in rush hour?

There is nowhere in Britain you would be able to shift it beyond second gear. And it's certainly no faster in a busy city than an elderly Skoda.

No, their appeal must simply be to provide a triumphant, macho aura to the gentlemen who own them.

Almost every young man and woman dreams of driving a lovely sports car, hood down on a nice day, sunshine and a warm breeze to lift the spirits high.

But the level of narcissism required to drive one of the current breed of eye-popping Lamborghinis and Bugattis goes beyond anything to do with a sports car.

Sports cars do not need startling neon colours, or to be covered in suede rather than paint, or have gold-plated wheels.

Yet, between the months of June through August, parts of London are filled with blindingly garish as well as blindingly expensive cars like this, competing to out-supercar each other.

In fact, this is now officially known as Supercar Season. A standard Ferrari gets little attention – the aim is to spot the most flamboyant car on parade.

Last summer, parked outside Harrods was a £1,000,000 black and gold Bugatti Veyron, a £1,200,000 acid-green Koeningsegg with gullwing doors, and a £900,000 Ferrari T60 America with a dazzling Swarovski crystal finish.

Lamborghini Aventadors in every electric colour of the rainbow circled

Knightsbridge, followed by an intimidating six-wheeled Mercedes G63 AMG, in gold mirrored paint.

The sound of roaring exhausts can be heard day and night, just before the screech of brakes as they approach a red light, or a bus as it stops to let off passengers.

The run from The Dorchester hotel in Park Lane to Knightsbridge and surrounding areas of Kensington is an unofficial street circuit.

The presence of these colourful beasts has infuriated local residents, who base their complaints on the grounds of noise and safety, rather than vulgarity.

Protests have become so vocal that the local council is even considering introducing a 'supercar ASBO' to try and curb the noise and disruption.

However, they are not unpopular with everyone. Enthusiasts from around the country head to London every summer to come and see the cars.

They gather in the evenings and capture these wonders on camera, as if they were models on a catwalk. This carparazzi prowl the few streets that make up the centre of the supercar parade grounds.

One fan has managed to turn his passion into a full time job, starting a YouTube channel, Supercars of London, which has been profitable enough for him to travel around Europe documenting the prime examples. He has even managed to afford to buy his own.

The drivers of the cars admit that they love showing them off, and the key is to have a car that is uniquely custom-tailored inside and out to demonstrate their refined taste.

Owners will even let the carparazzi ride in the cars and film the interior while they roar down the street.

And that is pretty much what it has become – a catwalk show for cars to be admired and photographed, the centre of attention.

Soon the supercars and their proud owners disappear, as the circus moves on to the next stops on the calendar, Marbella, Cannes and Monaco.

Hopefully the residents there are more welcoming than the long-suffering locals in central London.

Breaking the ice with your new neighbours.

Enjoying a pleasant relationship with your neighbours clearly makes life more harmonious. Helping build a sense of community is certainly more agreeable than ignoring, bickering or feuding with next door. A ready smile, easy smalltalk, even dropping off some home-made brownies or a casserole, these all help create a cosy togetherness.

But achieving tranquility is often easier said than done. There genuinely are neighbours from hell, immune to any charm offensive, people who are just aggressively troublesome.

And frosty relationships between neighbours appear to be commonplace.

A survey of British households revealed that over half of us are not speaking to at least one of our neighbours. Many admit to "not liking the look" of the people next door, so never consider talking to them. A significant number reveal they are involved in "a long-running feud" that has lasted at least four years. Most described it as a major row, though others thought it more of a petty squabble that had dragged on.

What sorts of squabbles? It's a lengthy list. Noisy children, barking dogs, cars parked unhelpfully, overhanging trees, overflowing rubbish bins, border disputes, unsightly disrepair – all are reliable causes of friction. In blocks of flats it will often be regular loud rowing and swearing, booming music, frequent and enthusiastic sounds of sex.

London is the home to some particularly tortuous neighbourly battles. Two

doctors in Forest Gate are at loggerheads over a hedge. After it had grown over 12ft in height along the front fence of a terraced house one of the doctors objected, politely asking her doctor neighbour to trim it back. She felt it was "blocking light coming into her house, and starving her plants of sunshine".

Her neighbour refused, on the basis that as a "green" person he did not want to interfere with nature.

Eight years on, despite court appearances, council orders and a judicial review, the hedge is still there – and is still growing. It is now a majestic 22ft, a towering presence on the street. The long-suffering neighbour claims that all she can now grow in her front garden are weeds, and that she needs her electric lights on during the day, to counteract the gloomy murkiness.

But the doctor who proudly owns the hedge is unmoved. He estimates that Newham council has spent in excess of £20,000 of public money in "conducting some kind of vendetta, and not behaving impartially" and won his appeal against cutting it back in the High Court.

On a more down-to-earth level, to many of us it seems neighbours are merely the strangers who live next door.

Two points worth remembering:

1. You will be more tolerant of your neighbour's noisy party if you are attending it – and vice versa.

2. Sometimes, conflict can be avoided by sending a thoughtful note. This was my favourite, placed on the Happyplace.com website:

Dear Neighbour,

Your car's sound system is amazing. It is so loud and the bass is so rockin' that it actually shakes all of the apartment buildings in the complex. Awesome! This is exceptionally bad when you pull up at 3:30 in the morning and wake up the entire community. Wicked awesome!

We are all very impressed with your super-cool sound system.

Don't even think about turning it down when you pull up to the building you share with hundreds of other people.

Your Envious Neighbours.

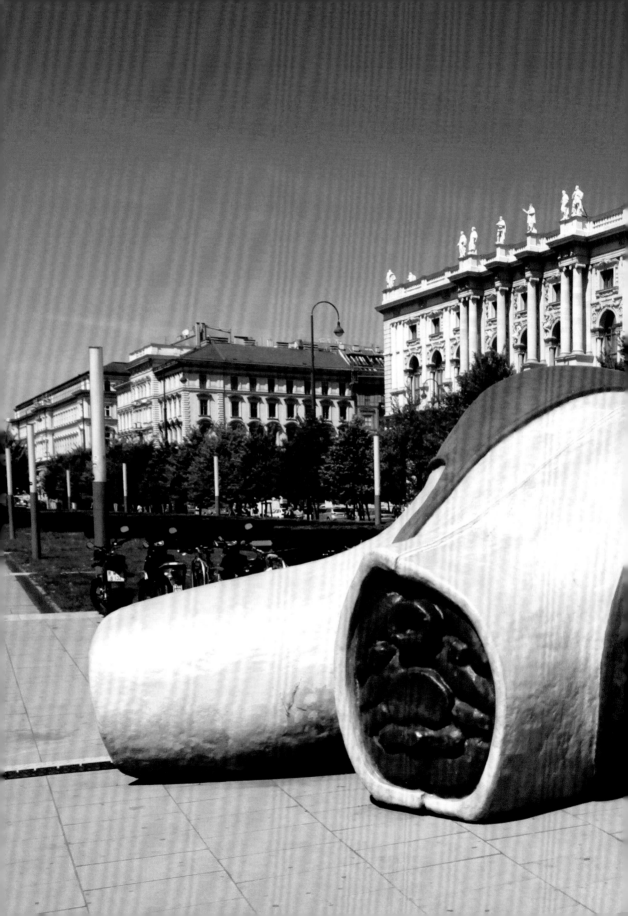

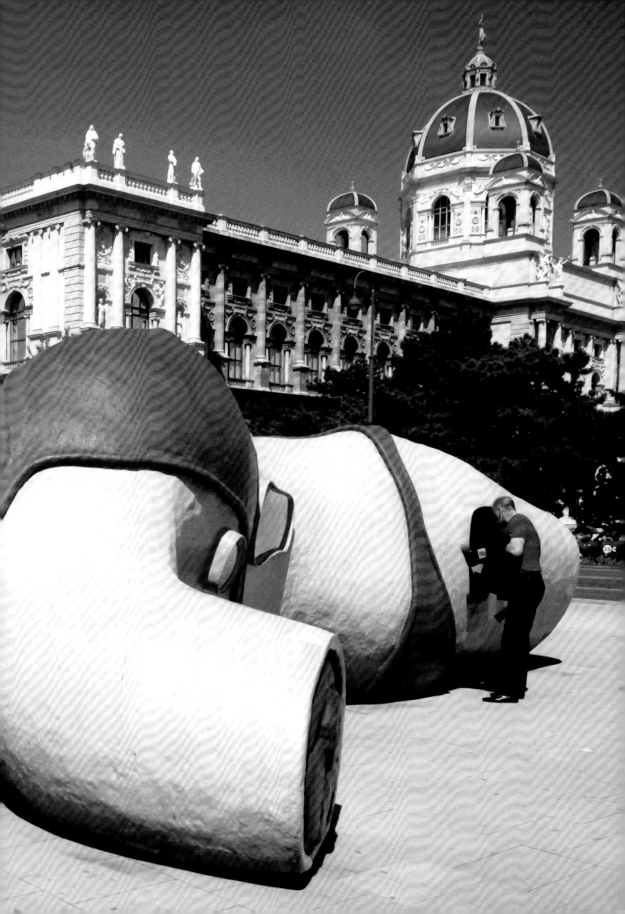

Is this the worst public sculpture in the world?

Would you like to see this sculpture placed opposite the Royal Albert Hall? Me neither. But a Dutch artist was commissioned to create the object pictured here for the elegant square near Vienna's Museums Quartier.

If you are ever in Prague, don't miss the bewildering suspended bronze sculpture of St Wenceslas, riding upon a dead upside-down horse.

Also worth a detour is a statue to be found in Enterprise, Alabama. Early in the last century little insects called boll weevils infested the region's cotton crops, utterly destroying them.

Farmers were forced to turn to growing peanuts and this quickly became such a success, Alabama began to see the insect scourge as a blessing. In appreciation, a statue was created, a 13ft tall monument of a woman proudly holding aloft a large black boll weevil above her head.

It is the only statue dedicated to a bug anywhere in the world.

There is, however, a statue made entirely of insect corpses in Gunma, Japan.

Twenty thousand of their dead bodies, looking like brightly coloured jewels, form a vast shimmering sculpture of the Buddha.

They took the artist almost six years to collect.

Even more repellent is The Child Eater, on display in Bern, Switzerland. It depicts a gentleman eating the head of a baby while holding a sack of understandably distressed-looking children.

It has alarmed both youngsters and adults for generations.

In Boston's Faneuil Hall marketplace, a 6ft red Mickey Mouse sculpture has been installed – with grimly bizarre lobster claws for hands, in honour of Boston's love of seafood.

In Chicago, a stainless steel and aluminium tribute to Marilyn Monroe was erected, towering 28 feet high.

It captures the iconic moment when Marilyn bashfully held down her dress as a gust of wind blows the skirt high up her legs.

Residents were vocal about their concerns, in particular the fact that passers-by were simply standing underneath to gaze up the screen idol's skirt. You can find dozens of photos online of grinning tourists standing below Monroe's pert bottom, admiring her white panties – before the sculpture was moved to California.

Even if you like artist Richard Serra's work as much as I do you can sympathise with residents in New York who objected to a massive Serra sculpture being placed in the small garden square outside their homes. It was a 100ft long, 10ft tall steel wall, called Tilted Arc.

Not surprisingly, locals were upset that they could no longer view the flowers and trees in their little park.

They made enough of a fuss that the authorities relented and removed the work, much to the general relief of all – even diehard lovers of avant-garde art.

In Britain, local councils throughout the land have bent over backwards to see which one of them could blight the landscape with the most unpleasant piece of communal art – in their efforts to commission something as spectacular as Antony Gormley's Angel of the North. So sadly, today the roll call of dismal public art the public are forced to put up with is a lengthy one.

Of course, the Eiffel Tower and the Parthenon in Athens caused outrage at the time they were first built; both were generally considered grotesque, and an utter waste of public money.

Perhaps, in decades to come, the sculpture pictured here will achieve beloved national treasure status in Austria, further illustrating my questionable judgement of art.

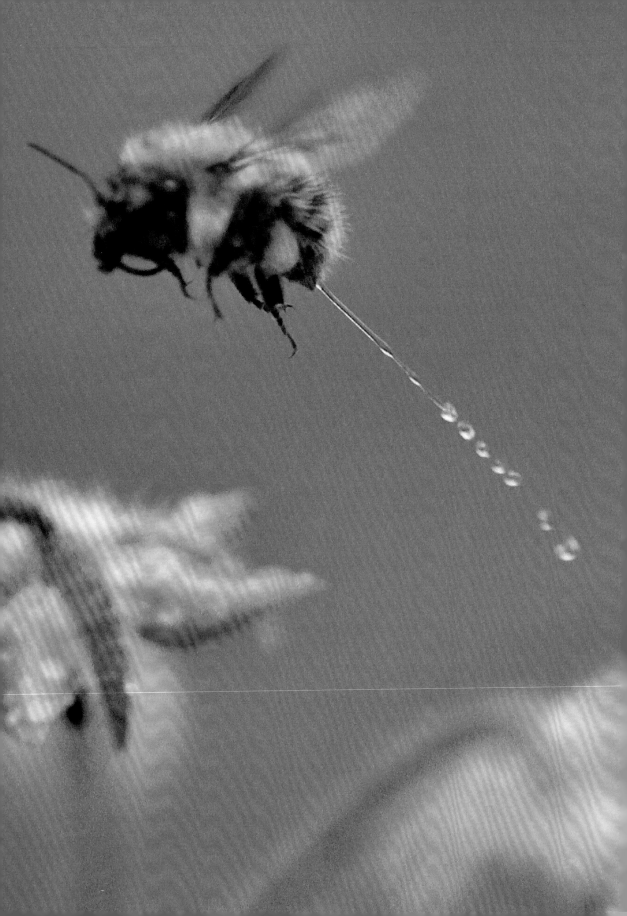

Bee pee.

Einstein believed that if bees disappeared from the face of the Earth, man would have only a few years to live: "No more bees, no more pollination, no more plants, no more animals, no more man."

China learnt the cost of using pesticides in its orchards – it has utterly destroyed the bee colonies across the giant Sichuan region.

Crops are now pollinated by hand using feather brushes – but not nearly as effectively or speedily as the bees were fulfilling this task.

In fact, across the world, a third of all farm produce relies on bee pollination.

Ever since mankind's earliest ancestors emerged and founded systems of belief, various apocalyptic scenarios have been used to bring populations to heel, and kept in fear of the gods.

From hellfire and anguish, to demons walking the Earth, the end of days has never sounded very appealing.

Most religions visualise much of mankind's doom being brought about by divine intervention – good news for the devout, bad news for the rest of us.

However, the newest theories about the extinction of the human race place humanity firmly at the centre of its own demise.

Climate change enthusiasts cling gamely to the belief that our ever-increasing output of carbon dioxide is reaching the tipping-point – pinpointed as central to complete environmental disaster.

Believers in the ensuing planetary chaos predict an "anoxic event", something that took place in the Jurassic and Palaeozoic times, when the seas become devoid of oxygen.

It is certainly the case that areas of ocean have appeared around the world in which there is not enough oxygen to support life.

Anxious biologists fear this will inevitably lead to the widespread death of marine animals – a food source for much of the globe.

Overpopulation stands as one of the most worrying extinction theories.

With the world's population now exceeding seven billion, having doubled in the past 50 years, the competition for resources will intensify.

But bee intelligence has mystified scientists for decades.

When a bee returns to its hive, it quickly communicates the location of desirable flowers using a 'waggle dance', first discovered by experts in 1979.

They found that a returning bee will make a distinctive wiggle of its abdomen as it twirls up and down the side of the honeycomb.

The movements pass on the direction and distance of the pollen source, as accurately as a car's sat nav.

Other scientists disagreed with this theory, suggesting that bees respond to sounds, but this finding was also discounted by researchers who claimed that it was odours that were used by bees to direct their hive-mates.

The controversy was finally resolved by teams at American and German universities, who devised robot bees to pass messages using the waggle dance, or to deliver samples of pollen, or to produce a vibrating sound similar to the beating of wings.

They discovered that bees can indeed 'hear', that both dance and sound provide information about the source of food, and also how it tastes and smells.

A bee with clipped wings raised the frequency of its sounds, and could not recruit other bees.

Bees have tiny brains obviously, but nevertheless they contain a complex system of over 200,000 nerve cells.

This enables them to form detailed cognitive maps to optimise the route around various flower locations, calculating the shortest distance while making multiple trips.

Clearly our own brains are not so versatile, as anyone who regularly gets lost driving on unfamiliar journeys will confirm – even if our satellite navigation system is doing its best.

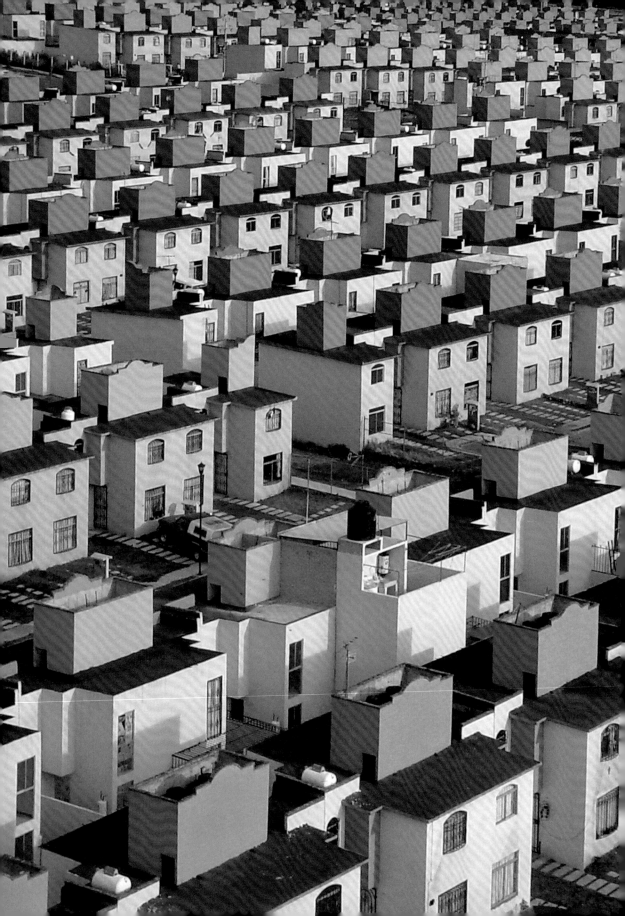

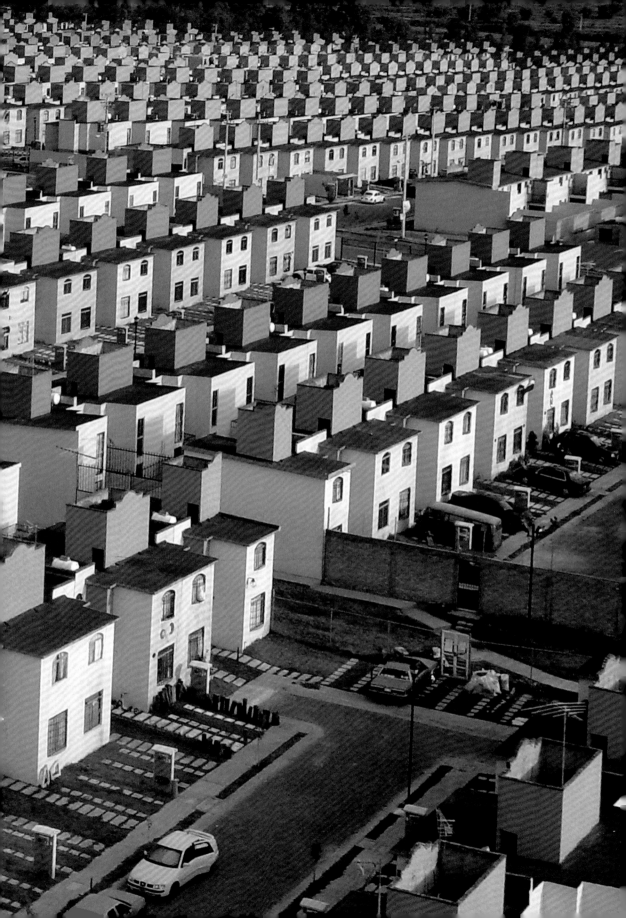

This isn't Legoland. It's Mexico.

This newly constructed suburb of Mexico City admittedly looks a little surreal.

The San Buenaventura complex is part of a national scheme to build two million homes for lowincome families – and 2,500 are being completed every day.

But if you have a taste for unconventional landscapes you really should visit North Korea. It is a land of vast superhighways, some with as many as a dozen lanes.

However, they are always empty as very few people in the country own cars.

Many more of its population look after the roads than drive on them: dusting the tarmac, pruning the shrubs, cleaning the gutters, tending the grass, creating the most meticulously presented highway system in the world.

Across our planet, 260 million people live in 30 giant cities. In 25 years, 70 per cent of the world's population will be living in megacities, or megalopolises as they are now to be known. If you live in one of the top 30, massive traffic jams are already commonplace.

In the Brazilian city of São Paulo last year, during a particularly severe road clog, jams reached 180km long during the busiest part of the week.

In Los Angeles, the AO5 Freeway is so notorious for its gridlocks that it is known as "Carmageddon".

It is hard for visitors to Mumbai or Beijing to determine which city has worse rush-hour traffic problems. Beijing is considered the more hazardous,

as it is often blanketed in smog, caused by a sandwich of exhaust pipes and pollution from heavy industry. Mumbai is the noisier, with many roads pot-holed, cars and trucks bouncing along every bumper-to-bumper journey accompanied by an incessant cacophony of beeping horns.

In North Korea, you will enjoy travelling in perfect tranquillity: 70 per cent of households use bicycles. According to a recent North Korean news report, its population is the second happiest in the world, behind China.

North Koreans rated the citizens of Cuba, Iran and Venezuela as the next most contented. They ranked South Korea as the 153rd happiest nation, and assessed that the least happy country in the world, placed bottom at 203, is the US.

On the country's official webpage it declares that "The Democratic People's Republic of Korea is a genuine workers' state in which all the people, peasants and intellectuals, are completely liberated from exploitation and oppression.

"They are the true masters of their destiny, in a nation which embodies the ideals and leadership of comrade Kim Il-sung, the founder of the republic and the father of socialist Korea."

Under his leadership, the regime killed more than a million of its citizens in concentration camps, through forced labour or by executing them.

In mitigation, Kim would have pointed out that his reign was a long one, dating back to 1948 – and that he was in power during the terms of office of seven Soviet leaders, 10 US presidents, 14 UK prime ministers and 21 Japanese prime ministers. Although North Korea clearly dislikes the US, its immediate neighbour, South Korea, is also very unpopular. One of the best preserved forest areas on the planet is the strip of land that separates the two Koreas.

This can be explained by North Korea having placed one million landmines along the border, therefore leaving the woodland understandably free from human activity.

Perhaps Kim Il-sung provided the world with a solution to one of mankind's greatest concerns – the wilful desecration of many of our planet's endangered rainforests.

Are you a crawler?

If you have the stomach for it, sucking up to your boss can be effective. But crawling requires subtlety.

Nobody likes a brown-noser, neither your colleagues, nor the recipient. Simply complimenting your superior's nice suit, or elegant shoes is unlikely to impress anyone – such attempts at ingratiating yourself will appear obvious and heavy-handed. Likewise, flattering the boss by enthusiastically agreeing with their every view can backfire if it appears you are being manipulative for your own ends. Better to look for ways to frame your admiration as though you are seeking advice.

"How did you manage to land such an important client?"

"What did you do to smooth over that disgruntled customer?"

This approach gives the impression that you are eager to learn from the master, to gain insights and improve, rather than being crudely fawning. Try to gain trust by disagreeing with a boss's viewpoint and presenting a well-considered but opposing opinion. Instead of being the stereotypical 'yes man', let the brilliance of their argument win you over, both validating your independence of thought, alongside their powers of persuasion.

When you then arrive at agreement, it won't come across as obsequiousness, but will demonstrate that you are both like-minded. Of course, you can certainly try arriving at work extra early and staying extra late, but this clearly requires too much actual effort if you are looking for a route to easy

advancement. Better to remember to always walk quickly around the office when you are speaking to colleagues, or if you are just visiting the water cooler.

People who do not act like they are engrossed, and always industriously working, will be the first on the list of potential redundancies if cutbacks are needed. Some basics: don't look hesitant when your boss has a new assignment for you, even if you are actually somewhat busy – just add it to your to-do list, and learn to prioritise.

Make sure your boss gets his pet project delivered on time, so that your skills, work ethic and commitment are remembered, when you are being considered for a raise or promotion. In fact, it seems most employers evaluate staff on their perceived job performance.

A recent study in the *Journal of Business and Psychology* surveyed 200 bank tellers and cashiers, and their 30 managers – and found that employees' contributions could be accurately assessed.

Supervisors are usually able to distinguish between members of staff who are 'good soldiers' and those that are 'good actors'. They can apparently determine which type you are – whether you are selflessly motivated to help the organisation and your co-workers, or whether you are self-serving and more focused on furthering yourself.

It helped dispel concerns that bosses may unfairly reward staff who are better at being sycophantic, over those who are simply efficient at their jobs.

Reliable rules to stick to are. 1. Don't be a wallflower, find the confidence to speak up at meetings and in staff activities, show that you can contribute ideas and suggestions. This way, you can be recognised as having value – rather than sitting mutely and looking uninvolved. 2. Don't give the impression that any task is beneath you, whether it is merely keeping on top of the filing, or getting the copier fixed. Avoid pulling rank, and do what has to be done even if it is menial or inconvenient – should you, for example, have to fill in when someone is off sick.

But whatever you do, don't make yourself irreplaceable.

If you're irreplaceable, you can't be promoted.

How to duck pickpockets.

London may be rife with gangs of pickpockets, but we don't even make the top ten most targeted capitals in the world.

Every traveller's best friend, TripAdvisor, has listed the 10 cities where you should be extra cautious about pickpockets.

Topping the chart is Barcelona, most specifically on Las Ramblas. One reviewer compares Barcelona pickpocketing to a generally accepted sport, like soccer.

Next sadly, is beautiful Rome. With its 'astounding historical and cultural attractions', it is all too easy for crooks to practise their ancient art of picking pockets, with just some sleight of hand, or a quick snip of some scissors.

In Prague the crowds that flock to the Charles Bridge, to take in the views of the Vltava River and Prague Castle, are a pickpocket's paradise.

Madrid, Paris and Florence make up the next three entries, with Buenos Aires and Hanoi as the only non European cities in the top ten.

To help you from falling into this unpleasant tourist trap, the helpful website also suggests some tips:

1. Never keep your wallet or cash in your rear pocket, even if it buttons – it's by far the easiest target.

2. Beware of the distraction tactic. Dropping something near you, spilling something on you, or simply jostling you.

3. Pickpockets often work in pairs or groups, and are hard to spot. Be cautious with any strangers – sometimes people who don't appear to pose a threat, such as children or the elderly, can be part of larger team.

4. Stay alert in confined spaces, and avoid standing in the crush of people waiting for train doors to open, or a bus to arrive; thieves use the clamour as a useful diversion to empty your pockets or handbag.

The world of shoplifters is an altogether more bizarre one.

For example, supermarkets report that the most shoplifted food item in the world is cheese.

According to Global Retail Theft Barometer, cheese – and raw meat – is stolen much more frequently than other foods.

There is apparently a demand on the black market for both these products. They don't receive the kind of protection that other desirable items are given, and store fridges are often inadequately covered by surveillance.

With the price of cheese and meat rising, the lucrative potential of a few wheels of Edam and a leg of lamb is proving irresistible to committed shoplifters.

According to the Centre for Retail Research, "It's not just grannies saying, I need some cheese and I'll just go and steal it. A lot of the theft is for resale and much of this cheese will be sold on to other markets or to restaurants."

However, supermarkets are doing their best to fight back. They have begun to security tag more expensive cuts of meat, as well as some pricey cheeses.

Alcohol, particularly whisky, vodka, and rum-based spirits are the next major goods preyed upon.

More mundane products such as cosmetics, lotions, shampoo are amongst the vulnerable categories, although razor blades, for years at the top of the most stolen lists, are now protected by display blocks.

Criminologist Ron Clarke coined the term Craved items – Concealable, Removable, Available, Valuable, Enjoyable and Disposable – to help stores protect their most enticing stock of earrings, scarves, leather goods etc.

It seems that the only way for retailers to defend themselves from professional shoplifters is to become security fortresses.

But clearly they feel this would tarnish the atmosphere of relaxed, carefree shopping.

So shoplifting becomes a cost of doing business, a cost simply passed onto us via higher prices.

Are children capable of sin?

Not as fully or frequently as their parents. For most children, their worst crime is smirking at you pityingly as they beat you at chess, when aged 12.

It's hard to say which of the Seven Deadly Sins we grown-ups are most guilty of. We normally take the sensible view that they are far from being sins; essentially they are all very uplifting and create a balanced and engaged life:

Pride – without it, what is the point of getting up?

Sloth – why get up when you can have a nice lie-down in front of the TV?

Envy – healthy in moderation, forgivable in excess.

Lust – are you joking?

Anger – a meltdown a day keeps the doctor away – fact. I read it in the *Daily Mail*, so it is obviously true that losing your temper regularly is an important aid to avoid stress and heart attacks.

Greed – hardly a sin unless it turns you into a sex-slave trafficker, drug baron or simply a serial mugger.

Gluttony – is right up there with lust.

Strict adherents to the biblical commandments would have to believe that stealing to feed a starving child is wrong.

But if you're looking for a crime here, what about the world's most vile people, who pocket millions given in charitable aid to help feed the needy and end up feeding a few Swiss bank accounts instead?

There are many, many people in need of a bit of retribution, before we have

to start a vigilante group to hunt down mothers who steal some bread for their hungry children.

It is unforgivable that anybody in the modern world lives in famine, or without medical support; politicians everywhere are completely ineffective in doing much about it – or in stemming the widespread corruption that makes a mockery of other people's hardship.

Man's inhumanity to man suggests that our race has not evolved as well as we might have hoped.

The artist Pieter Bruegel was captivated by the wickedness of mankind. His wonderful 1559 painting *The Blue Cloak* depicts a land populated by renditions of Flemish proverbs of the day. They offer unexpected words of wisdom when translated into English:

One shears sheep, the other shears pigs: one has all the advantages, the other none. The herring does not fry here: things do not go according to plan. The scissors hang out there: that's where they are liable to cheat you. There stand the wooden shoes: to wait in vain. To have toothache behind the ears: to be a malingerer. To be a hen-feeler: to count one's chickens before they hatch. To have a hole in one's roof: to be unintelligent. To shave the fool without lather: to trick somebody. She puts the blue cloak on her husband: she deceives him. To be a skimming ladle: to be a parasite or sponger. To catch fish without a net: to profit from the work of others.

As it happens, I think that the Seven Heavenly Virtues make pretty stagnant fare as a code of practice for society.

Chastity – suggests a stolid and antiseptic life. Worthy, but a trifle colourless.

Temperance – permanently being sober sounds pretty sombre to me.

Charity – lovely, and nice work for people seeking knighthoods or a sense of self-regard.

Kindness – lovely, but malevolent people are more intriguing.

Diligence – sounds exhausting.

Humility – why?

Patience– if it's worth waiting for, it's not worth having.

Britain's favourite takeaway.

Fish and chips once again tops the list of the country's most popular takeout food.

It has battered its competition, after a decade of Chicken Tikka Masala ruling the roost.

In fact, Chinese takeaways have pushed Indian foods into third place, followed by Pizza, Thai, Kebabs, Fried Chicken, Burgers, Sushi and Italian meals.

Birmingham remains the national curry capital, but London prefers Chinese food, with fish and chips coming a close second in both cities, and No. 1 overall nationally.

When you consider the variety of cuisines now readily available in Britain's towns, it makes our enduring love affair with fish and chips charmingly touching.

And we are unique – nowhere else on Earth does the dish enjoy anything like the same level of affection.

Britain has become more open-minded about our food choices, as we happily try everything from Korean street food to Tex-Mex specialities.

But you are still unlikely to be offered the fish shown here – either fried with chips, or rolled into bite-size sushi rolls.

The Blobfish from the seas around Australia is somewhat hurtfully ranked as one of the planet's ugliest creatures. But surely it just looks rather like a grumpy older man, possibly reminding you of someone you know.

A good takeaway seems to be at the heart of modern British culture.

Have our lives become busier, with less free time than earlier generations? Is there too much easy entertainment at home on T.V or our computers?

Or are we simply getting lazier, can't be fagged to cook a meal, not after a long day of work and the battle of a commute?

According to a study into the money we spend on food – groceries, in cafes, and restaurants – it was found that almost £30 billion each year goes on takeaways – a third of our entire food budget.

Both how, and what we eat in the UK has evolved rapidly since the days

when dining out was a rare treat, and choices were limited.

In the 1960s a few Chinese and Indian restaurants began to expand from just catering to their own nationalities in local neighbourhoods, to now be regular fixtures on every High Street.

It certainly made a tantalising change for Londoners from the typical eel pie and mash restaurants in the East End, or the game, oysters and roast lamb served at establishments like Rules, London's oldest restaurant.

Soon, Italian trattoria began appearing everywhere, and since then we have become a nation fascinated with different types of cuisine. From adopting spaghetti Bolognese as a standby in the 70s, to the microwave meals in the 80s, two things became clear.

As a country, we are no longer scared to try unfamiliar food, and when we are not cosying up with a takeaway, we are open to try groundbreaking new cooking.

Diners battle for a table at the newly hip restaurants run by superstar chefs, to enjoy creations such as a macaron of aerated beetroot, or Jerusalem artichoke ice cream with cumin panna cotta.

Since the first Michelin stars were granted to British restaurants in 1974, we now have around 66 of them in London alone, and dozens across the UK.

Even our humble fish and chips have had a makeover. Chippies often take an interest in interior design these days, and offer a pleasant dining experience, if you don't want to just take some nice cod and chips back home.

Three names continue to pop up – Toff's in Muswell Hill, Kerbisher and Malt in Shepherd's Bush and Poppies in Spitalfields.

Expect queues, but no Blobfish.

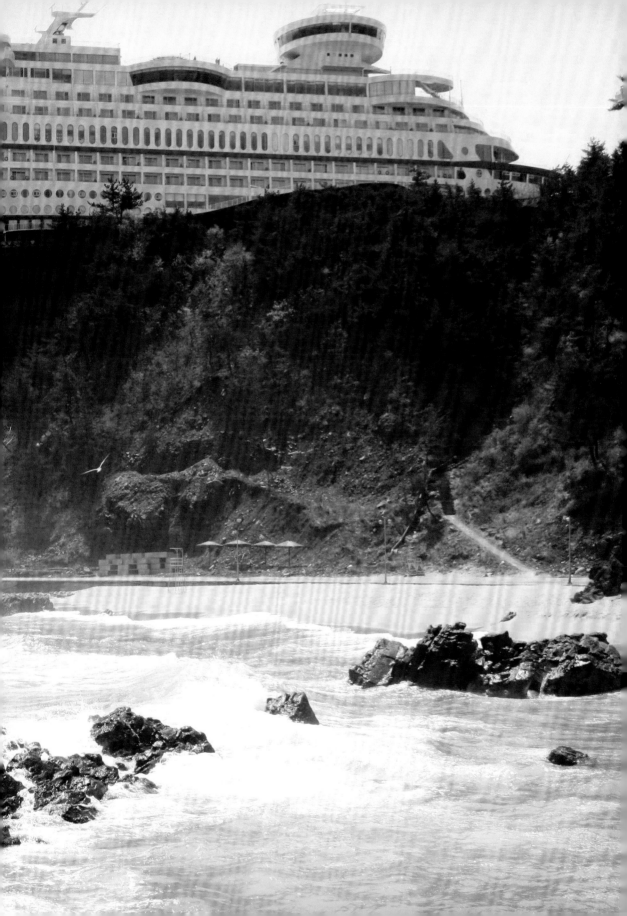

The great cruise ship mystery.

Often the most perplexing of riddles have the most mundane of explanations.

This passenger liner, perched on a cliff top, didn't just get dropped off here by a mammoth tsunami or a giant tornado. No, it is simply a hotel in South Korea that has been designed, both inside and out, to look like a spectacular cruise ship.

But there are a surprising number of mysteries on Earth that science and logic have failed to unravel.

There is the Voynich manuscript – a handwritten book thought to have been created in the early 15th century and comprising about 240 vellum pages, most with illustrations.

Although many possible authors have been proposed, the actual language, script and writer remain unknown.

Generally presumed to be some kind of ciphertext, the Voynich manuscript has been studied by many professional cryptographers, including American and British codebreakers from both the First and Second World Wars. Yet it has defied all deciphering attempts, becoming a historical cryptology cause célèbre.

Recently, University of Arizona researchers performed carbon-14 dating on the manuscript's vellum, which they assert (with 95 per cent confidence) was made between 1404 and 1438. In addition, the McCrone Research Institute in Chicago confirmed by testing the ink that the manuscript is an authentic

medieval document. It is housed in the Beinecke Rare Book and Manuscript Library of Yale University, should you want to have a go at translating it.

If you believe in ghosts, alien abductions, psychic phenomena and the like, you will be intrigued by the reports of the Overtoun Bridge dog suicides.

Stretching across the Overtoun Burn in West Dunbartonshire, Scotland, the bridge gained notoriety because of the large number of dogs that have leapt to their deaths from it over the past decades.

It is not known exactly when or why dogs began to hurl themselves from the bridge, but studies indicate that these deaths might have begun during the Fifties or Sixties, at the rate of about one dog a month. The long dive from the bridge onto the waterfalls below almost always results in immediate death.

Inexplicably, some dogs have actually survived, recuperated, and then returned to the site to leap again. These dogs are known to the locals of Dumbarton as "second timers".

The dogs have mostly jumped from one side of the bridge, during clear weather, and all have been breeds with long snouts.

The phenomena received international attention and the Scottish Society for the Prevention of Cruelty to Animals has investigated, but no satisfactory explanation has yet to be found – and dogs keep leaping still.

The Antikythera Mechanism was recovered in 1900 by sponge-divers from a shipwreck off the coast of Crete. It was a corroded bronze structure composed of many cogs and wheels.

Scientific testing of the object indicated it was certainly made in 80BC, but an X-ray of the machine revealed it to be highly complex, with a sophisticated system of differential 16th century.

Yes, the Mechanism, the Voynich manuscript, the equally baffling Grooved Spheres found buried in South Africa, the spooky Dropa Stones discovered in China – most people would be confident they are probably all elaborate hoaxes.

But who would have believed Koreans would want a hotel that is a replica of an extremely big boat?

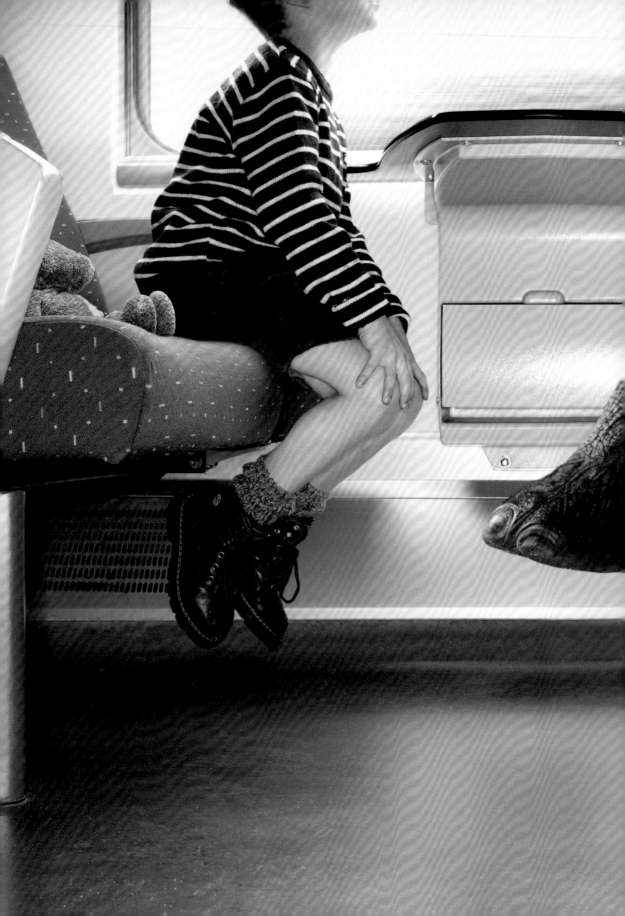

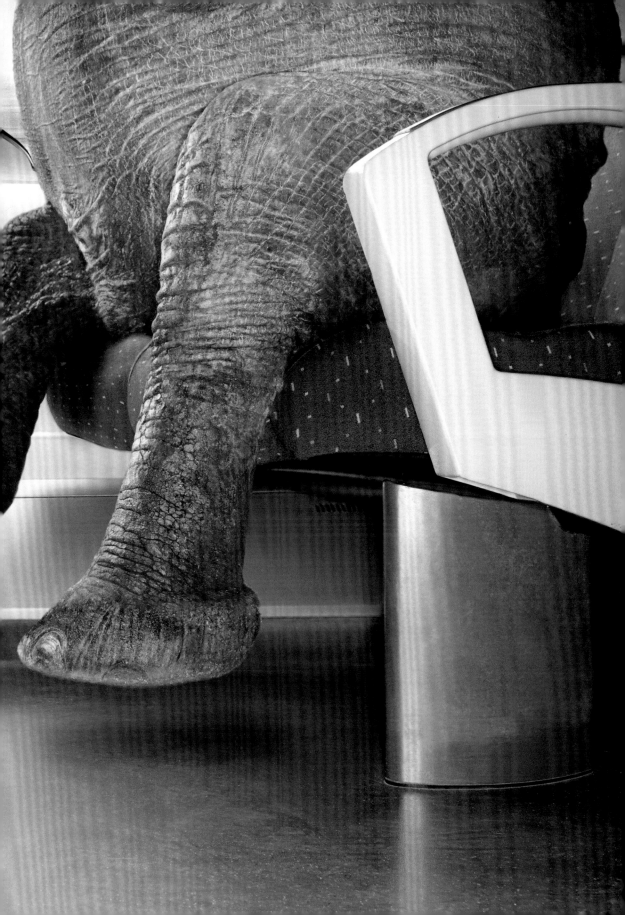

Did you have an imaginary friend?

It's more common than we would think. A study in Britain of 1,800 children reported that 46% had an invisible friend.

Even at age twelve, almost 10% of children reported still having one. These figures are startling to adults who didn't share this experience, particularly to parents who unconsciously project their own experiences of childhood onto their children.

Other adults may find it difficult to empathise with the very young, and simply assume that the 'invisible friend' syndrome is quite rare.

Imaginary friends can be human, animal or fantasy creatures, be readily described, and be part of the life of a child and the family for years.

A youngster tends to imagine a real relationship, where the invisible friend doesn't always cooperate, won't always come when they are called, or won't leave when asked, can be too noisy, doesn't always share, and can do annoying things like 'put yoghurt in my hair'.

However real these friends may seem, almost all children know their imaginary friend doesn't actually exist.

In a U.S study, of the 77% of children who said that they had an imaginary friend, well over half spontaneously remarked sometime during their interview that they were talking about a pretend friend. 'He is not in real life'. 'I just made him up in my head.'

Dr Eileen Kennedy-Moore, who specialises in child psychology, offers

useful insights to anxious parents about this phenomenon.

You would assume that it is just lonely children that create pretend playmates, but research shows no such correlation. In fact, children with imaginary companions tend to be less shy, engage in more laughing and playing with their peers, and are better at working out how someone else might think.

Children who don't watch a lot of television, and with some unstructured time alone, are more able to invent imaginary friends.

It is by no means a sign that a child is troubled – in fact such friends can be a source of comfort while a child is experiencing difficulties, or coping with a traumatic experience.

Professionals advise parents to be relaxed about this extra family member – to see it as a unique and magical expression of your child's imagination.

Ask questions to find out more about the friend, and you may learn something about your child's current interests, fears or concerns. But don't let the imaginary friend become a disruptive excuse for bad behaviour.

Without challenging the existence of the pretend friend, say things like 'I don't care who made this mess, you need to clean it up.' Or 'Aunt Carol is coming in the car with us, so Mr. Bibble will have to find somewhere else to sit today.'

But generally, try and play along. Set an extra place at the table, but don't try to closely engage with the invisible friend – leave your child in charge of it. It gives children a refreshing opportunity to take control, helping them to fulfil their wishes by invention.

It also can boost their confidence, and lets them thrash out a dispute they may be having at school by being able to talk things over with their own 'playmate'.

Sadly, almost all of us tend to have our pretend friends fade away as we get a little older.

Wouldn't it be so much handier to have an interesting imaginary pal to chat things over with whenever we feel dull, or troubled, during our lives – rather than bore our real friends?

Singing a different tune.

Don't you get irritated by that insistent plea for us to all to sing from the same hymn book? It celebrates the joys of uniformity, and rather like sheep we are implored to follow the herd.

But interestingly, people who choose to zig while others are zagging seem to find success with some regularity. Following an unconventional, non-conformist path is hazardous and often doomed – but it also happens to be the passage taken by mankind's greatest thinkers and innovators.

Once, being a non-conformist simply referred to Protestant Christians who did not 'conform' to the governance of the established Church of England.

Conformity is obviously a powerful social force, that offers some self-protection especially in uncertain times.

Psychologist Solomon Asch's well-noted studies in the 1950s showed that people will change their correct answer to a question if they are part of a group that firmly believe in the wrong answer.

But as times changed non-conformity had became more commonplace.

For Elizabeth Garret Anderson, her days should have been filled with needlework, child-raising and other routine lady-like activities in mid 19th century Britain. Instead she calmly decided to pursue a career in medicine, becoming the first woman in Britain to pass the examinations required to obtain a licence as a medical practitioner. However, she was firmly blocked from taking up a post in any hospital, on the basis she was female.

Instead she decided to open up her own practice, the first woman GP, and her success soon inspired other women to follow her lead.

Education and secure employment was not a path that appealed to young Heather Gillette. After dropping out of school and running away from home, she talked her way into working for a new company just starting up –YouTube. She learnt on the job, rose high as the organisation grew, before going on to start her own thriving business in online interior design.

Daniel Ek was already on his way to changing the music industry when he was just 16 years old. He began asking himself, how do you get people to pay for music that can, easily but illegally, be downloaded free?

After finishing school, and trying a short stint at university at the Royal Institute of Technology in Sweden, his desire to become an entrepreneur compelled him to leave and strike out on his own.

The seed that had been growing in 16-year-old Daniel's mind was to become Spotify, the website that revolutionised the music business. It changed forever the way people across the world listened to music. After launching in the US in 2011, Spotify was valued at $3 billion within a year. It was already streaming 20 million songs for customers to select from. Daniel retired while in his mid-twenties.

Despite coming from a privileged background, Travis Kalanick deviated from the path set for him by his parents when he dropped out of UCLA. He joined some of his classmates to found a multimedia search engine and file-sharing service. A powerful lawsuit was suddenly brought against them, and they were forced into bankruptcy.

Kalanick didn't return crestfallen, to slip into the safe, lucrative career he could have been provided with. Instead he persevered with the tech knowledge he had accumulated, eventually finding success by bringing us Uber.

He found a new route to go with his unorthodox innovation, on roads already crowded with taxis and minicabs.

And now, much of the world is hailing his company's cars, singing to his hymn book.

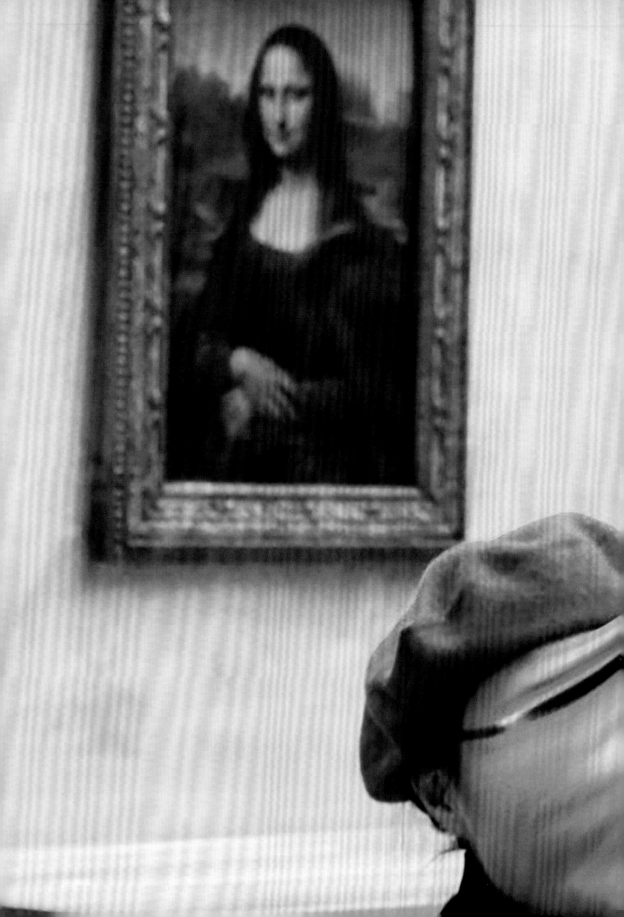

Are selfies sucking the life out of us?

To a narcissist, Facebook and Instagram are like an open-bar to a drunk.

Our celebrity-seeking generation seems hooked on preening and posing for self-portraiture, to be seen and shared by as many strangers as possible.

Of course, this is nothing new. Tom Wolfe, the great diarist of the modern age, piercingly declared that the 70's were the 'Me Generation', populated by baby boomers who were self-absorbed, swaggering and arrogant, in equal measure. But perhaps each decade simply appears to be more self-regarding than the previous one?

Millennials, people currently aged 18–34, have been described as 'the most selfish generation in history' – and the millenials seem to agree.

60 per cent of them describe their peers as 'self-obsessed'.

Young men who would never define themselves as high-maintenance or vain, and young women who are confident enough to dress effortlessly and go make-up free – they all sill manage to fall victim to internet vanity. They carefully monitor and edit the images of themselves loaded onto social media, and do so with painstaking devotion. Most are aware of the best angle for their face to be viewed, the best filters to employ to enhance their picture, the best photoshopping tweaks that can improve 'their look' imperceptibly.

Would our grandparents have become this self-regarding if they had grown up in the age of the internet? Almost certainly.

According to a 2013 study by ComScore, 20% of Britons online at any

moment are over sixty. They have smartphones, they have Facebook profiles.

They share their holiday snaps with the world via their iPads, onto Snapchat, Instagram, Twitter, Pinterest. Perhaps this is the clearest indicator that the coming generations will find all this community sharing decidedly uncool, and turn their backs on such levels of self-aggrandising.

Researchers at Florida State University have found that the more selfies you post on Instagram, the more likely you are to experience conflict in your romantic life.

Too much selfie exposure apparently embroils you in jealousy and arguments. Other studies helpfully point out a number of guidelines: Don't try and fake your reality. What is the point, after all? Don't share your sadness – social media is not a forum for misery and unhappiness. Save it for face-to-face social relationships with a patient listener. Don't let social media distract you from real life. Instagram is not a friend, it's a set of algorithms. Don't accept every 'like' request that comes your way, in order to build the number of your followers and appear much admired and respected.

Far better to restrict your Facebook profile to people you actually know, and only follow Instagram accounts with pictures you actually want to see, posted by people you actually care about e.g. not Paris Hilton.

Don't believe all that you read online. These days, we are all authors with something to write about – but many of us are writing fiction and fantasy.

Don't post details of your life that could fall into the wrong hands.

You wouldn't put a note on your front door saying 'Away for the weekend… back on Monday'.

Seemingly innocuous pieces of information can be pieced together, giving lurkers a complete picture of you, your family, your habits, your possessions, and other personal information.

Social networking sites are free to use, so remember that they only make money by selling you as a target for advertising and marketers.

When you wade through acres of spam each time you open your inbox, it isn't because you are wildly popular – you are merely a potential cash cow.

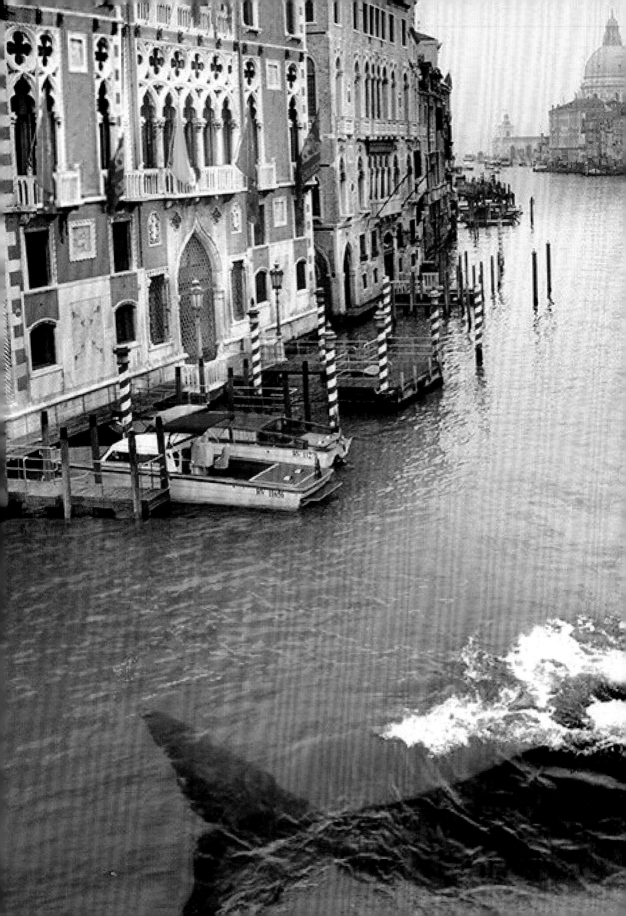

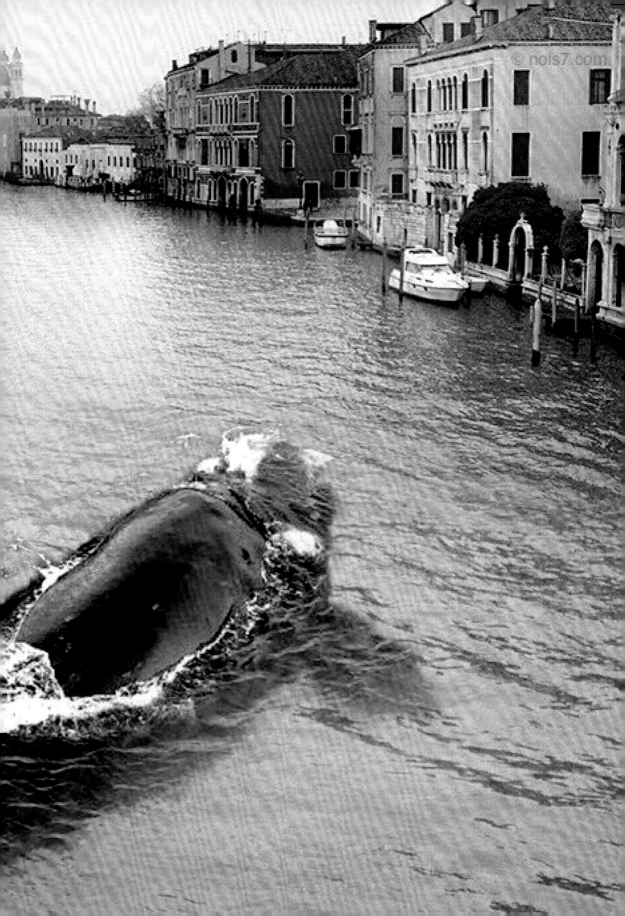

The Venice menace.

Venice is drowning – but not in the way we anticipated.

In fact, water levels in Venice have hit record lows, its canals dropping significantly in depth in recent years. Of course, this utterly confounds the experts who predicted that Venice was perilously sinking, soon to become waterlogged by catastrophic global warming.

However, Venice genuinely is being sunk, by the steady influx of 20 million visitors a year. Half of them come as day trippers, many arriving on mammoth cruise liners. These behemoths of the sea dwarf the exquisite floating city as they park up; they then engorge their thousands onto Europe's most popular destination for vacation liners.

Venice now has fewer than 60,000 people living there, less than the number of daily visitors. More Venetians have moved out of their city than there are Venetians left behind.

The reason? They love their town, but they value their sanity more – and mass-tourism has left them crazed with frustration. Their magical city is now packed with jostling crowds, rammed like rush-hour tube train commuters round the enchanting canal-side streets, the shops screaming with tourist tat.

The hordes shuffle round Venice's must-see highlights, gawping and snapping pictures, vacantly oblivious to the wonders they are supposedly experiencing. You don't have to be an aesthete, or a cultural snob, to sense the Venetians' dismay.

Of course, Venice wants its visitors that provide residents with work, and profit. But at least half of the tourists are there just for the day, and don't use the town's hotels or even its restaurants, eating at fast-food burger chains, or bringing a packed lunch in their backpacks.

The crisis in Venice is so desperate that the city council are considering charging an entry fee to the city, ticketing the town as though in acceptance of its role as a cheesy theme park for the rest of the world.

Of course, Venice is far from being the only historical jewel that has had to face the perils of becoming a tourist trap.

China's Forbidden City had been closed to outsiders for centuries. When Beijing opened its doors in 1925, it quickly made its way to become one of the world's most popular tourist destinations. Nowadays, the crush to see the Emperor's Palace is endless, with queues forming for hours to get a peek inside.

However, there is a Starbucks within the Forbidden City's walls, if you are craving a latte, and don't mind being crammed into the long lines waiting to get served.

Every day, about 5,000 people flock to the deserts of Egypt to see the Pyramids. Your only option to avoid being trampled by the crowds at all the choice sightseeing spots is to take a camel ride, or view the sites through binoculars.

The speed with which a pretty fishing village like St Tropez can be transformed into a pinnacle of vulgarity is bewildering.

Like Cancun in Mexico, home to some of the nicest beaches in the world, just a couple of decades turned this remote idyll into a suffocating tourist trap.

Cancun is now renowned for having some of the most unpleasant tourist infrastructure anywhere on earth.

The writers of the *Rough Guides* and the *Lonely Planet* tourist books must wonder if they destroy the unspoilt places they discover by sharing them with the world. By driving people to the next "undiscovered" place, like Ko Phi Phi in Thailand, when they return they must end up saying, "Man, this place used to be so cool 10 years ago."

Is the world getting more equal?

Inequality is apparently inevitable. If everyone were equal, the argument goes, who would choose to undertake the unappealing tasks that no one really wants – sweeping streets, cleaning lavatories, picking up other people's trash?

Obviously disproportionate wealth creates a divide, and this unjustness prevails globally. But it is surprising that countries we think of as being comparatively impoverished appear to have far happier citizens than those in more advanced, and far richer, nations. The Happy Planet Index from the New Economics Foundation shows the extent to which 151 countries worldwide produce "long, happy and sustainable lives" for their inhabitants. It ranks each nation on three component measures: life expectancy, the experience of wellbeing and the ecological disruption created by its citizens.

Costa Rica was ranked as the happiest place on Earth, yet it is a country with a GDP of only $45 billion, a modest sum by most standards. Second is Vietnam, followed by Colombia, Belize, El Salvador, Jamaica, Panama, Nicaragua, Venezuela and Guatemala.

The World Intellectual Property Organization publishes the Global Innovation Index, ranking each country by its ability to invent new ideas and patent them into fruition.

Of course, heavyweights such as the USA, the UK and Germany tend to monopolise the table, with developing countries falling well behind.
But the organisation also publishes an Innovation Efficiency Index, and the leading nation that is regularly able to create worthwhile breakthroughs for next to nothing is Mali. A significant achievement indeed because Mali remains one of the poorest countries on Earth, in the bottom 25 of the least well-off nations.

Defiantly, in science and technology Mali is remarkably resilient and capable of wringing more value pro rata out of a small investment than China.

In the area of gender, injustice worldwide seems to persist, though the gap is slowly closing. Annually, the World Economic Forum publishes the Gender Gap Index, producing a set of international rankings that measures equality between the sexes. It aims to indicate the nations where women fare best and,

unsurprisingly, Nordic European countries usually dominate this category. But at the head of the top 10, the Philippines is the most female supportive country in the world. The UK, Canada, America, Australia and most of the EU all rank significantly lower in terms of equal opportunities between men and women. Perhaps more advanced economies could take a little advice from some developing countries when it comes to equality.

Azerbaijan has an ancient and historic cultural heritage, being the first Muslim-majority country to have operas, theatre and ballet. It is stereotypically thought of as a corrupt and oil-rich state. Its capital city, Baku, is renowned for its nepotism, cronyism and human rights abuses. Oddly, it also seems to have the highest literacy rates in the entire world.

The CIA's World Factbook claims that 99.8 per cent of the adult population of Azerbaijan can read and write – a number that makes the UK, Japan, Australia and the United States seem backward by comparison.

Usually we associate a lack of democracy, widespread state censorship and pervasive surveillance with developing nations ruled by totalitarian dictators and fascist ideologues.

Privacy International publishes a global survey examining levels of government snooping on its citizens.

Britain was ranked "black" or "endemic" for the second year in a row, one of the top "spy states" in the world, alongside the US, China and Russia.

Results from the Global Burden of Disease report revealed a growing shift in global health, where increasing obesity levels have become a greater concern for health experts than death caused by a lack of fresh water or starvation.

Tragically, even if in the past 20 years "a billion people have been lifted out of poverty", a billion more have ended up gorging themselves into a premature grave.

We have created a new, overfed world – a global pandemic shared across many countries – with no single nation seemingly willing to tackle this blight.

Meanwhile, researchers measuring intelligence in the animal kingdom believe that a number of species are now evolving faster than mankind.

An earring to improve your hearing.

Startlingly, over 11 million people in Britain have some form of hearing deficiency.

The Action on Hearing Loss charity estimates that 6.7 million of us could benefit from hearing aids.

The World Health Organization reports that 350 million people around the world have disabling hearing loss, but that current supplies of hearing aids and cochlear implants meet less than 10% of the global need.

On average, it takes people about 10 years to begin to address their hearing deficiency.

It is a reality to bear in mind when you find yourself struggling to follow conversations at a cocktail party, or are constantly being chastised for having the TV too loud.

Beside the numerous medical causes of deafness, the most recent generations are victims of excessive noise – mainly recreational.

Rock concerts, dance clubs, noisy restaurants and bars, music played loudly on your headphones – all are as damaging to your ears as manning a heavy-duty road drill for years, without ear protection.

But your hearing can even be permanently harmed after just a single exposure to an extremely loud noise, say a shotgun blast, or an explosion.

Professions most at risk of damaged hearing include firefighters, police officers, industrial and construction workers and military personnel.

Even driving a convertible can harm your ears over time, according to Dr Philip Michael, a specialist surgeon at Queen Elizabeth Hospital in Birmingham.

Wind roar and buffeting present a cumulative risk, he explains, and 'the more you drive with the roof down, the more chance you have of developing permanent problems'.

Why won't more people who can afford hearing aids, or are eligible for NHS assistance, wear them?

People respond that they can 'hear all right', even during the course of a conversation in which a much-raised voice is necessary.

Denying or minimising hearing-loss by patients is one of the challenges many physicians have to overcome.

Generally, people feel a hearing aid will make them look old – it implies you are mentally and physically desiccated and dependent.

But surprisingly, the majority of individuals suffering from some deafness are under the age of 65.

Trying to remain fit and vigorous is important to most of them, so constantly signalling to yourself and others that you are growing old is hard to accept.

Despite the minute size, or invisibility of modern hearing aids, they are still resisted – it is the daunting acknowledgement of hearing impairment that many sufferers cannot cope with.

As specialist Dr Mark Ross points out, 'They continue to miss and misunderstand everyday conversation; their social and cultural activities gradually diminish, and their lives become more and more restricted.'

'The attitude is self-defeating – their conversational partners may ascribe their confused communication to senility.'

'People can also make incorrect assumptions that you are a bit dim, when the point of a conversation is missed or a question answered inappropriately; even that you are rude when you fail to respond to greetings and suchlike.'

An alarming number of musicians, particularly those who regularly play heavy-metal music to stadiums of fans, are growing deaf.

Of course, to many members of the global superstar rock bands, deafness can be worn as a badge of honour.

Perhaps, if the Rock Gods could be persuaded to start wearing their hearing aids with pride – a symbol of their authenticity – coming generations will be more accommodating to doctors who want to offer help.

And then, if hearing aid manufacturers could be more creative as seen in the photo here, perhaps a little deafness might appear acceptably cool.

The perfect break-up letter.

This was the correspondence between a couple on the verge of a marital breakdown.

Dear Wife,
I'm writing you this letter to tell you that I'm leaving you forever. I've been a good man to you for seven years and I have nothing to show for it. These last two weeks have been hell… Your boss called to tell me that you quit your job today and that was the last straw. Last week, you came home and didn't even notice I had a new haircut, had cooked your favourite meal and even wore a brand new pair of silk boxers. You ate in 2 minutes, and went straight to sleep after watching all of your soaps. You don't tell me you love me anymore; you don't want sex or anything that connects us as husband and wife. Either you're cheating on me or you don't love me anymore; whatever the case, I'm gone.
Your Ex-Husband.
P.S Don't try to find me. Your sister and I are moving away to together. Have a great life!

Dear Ex-Husband,
Nothing had made my day more than receiving your letter. It's true you and I have been married for seven years, although a good man is a far cry from what you've been. I watch my soaps so much because they drown out your constant whining and griping. Too bad that doesn't work. I did notice when you got a haircut last week, but the first thing that came to mind was 'you look just like a girl!' Since my mother raised me not to say anything if you can't say something nice, I didn't comment. And when you cooked my favourite meal, you must have gotten me confused with my sister, because I stopped eating pork years ago. About those new silk boxers: I turned away from you because the £29.99 price tag was still on them, and I prayed it was a coincidence that my sister had just borrowed £30 from me that morning. After all of this, I still loved you and felt we could work it out. So when I hit the lotto for £10 million, I quit my job and bought us 2 tickets to Jamaica.

But when I got home you were gone... Everything happens for a reason, I guess. I hope you have the fulfilling life you always wanted. My lawyer said that the letter you wrote ensures that you won't get a penny from me. So take care. Signed, Your Ex-Wife, Rich as Hell and Free!

P.S I don't know if I ever told you this, but my sister Carla was born Carl. I hope that's not a problem.

Divorce is a confusing business to get your head around.

On one hand, divorce is at an all-time low, especially for those married since 2000 – divorce rates have fallen to their lowest level for 40 years. But on the other hand, the rate of marriages ending in divorce has increased – for those marrying between the late 1960s and the late 1990s.

Experts explain this anomaly by pointing out that growing numbers of couples are cohabitating before getting married, and this has ultimately strengthened their union.

In fact, there has been a rise in the number of weddings over the last few years, reversing the trend of declining marriage and rising divorce.

Nonetheless one matrimonial law firm's study (not the legendary Ditcher, Quick and Hyde) reported that 'growing apart' and 'falling out of love' still account account for about a third of divorces.

Apparently, that is more commonplace than having a husband run off with his wife's sister.

Storms in a teacup.

Is tea good for you? Is it very bad for you?

A quick scour of the published data shows that both viewpoints have acres of support.

Assuming that the 'dangerous tea' advocates aren't sponsored by the Coffee Growers Association, each side presents compelling arguments.

But as a nation we run on tea, so first a look at the good news:

Research show that tea drinkers have stronger bones, and therefore have a lower risk of fractures, including displaced hips.

The International Osteoporosis Foundation, who are bewitched by all things boney, estimate that more than 200 million people worldwide have a debilitating bone disease.

Drinking just 3 cups a day has been linked to a 30% lower risk of bone weakness.

Plant chemicals in tea strengthen the body by speeding up the building of new bone cells, and slowing down the erosion of existing ones.

These chemicals are also good for the heart, with evidence that consuming 4 cups of tea a day can reduce your chance of having a heart attack.

It is apparently crucial that what you are drinking is actually tea. Only green, black, white and oolong count.

Sadly for enthusiasts of the herbal variety, this isn't technically looked upon as tea – it's an infusion of the plant.

Green tea is high in antioxidants that hunt down dangerous cells, keeping our cholesterol low.

Many claim tea has mystical powers to aid our concentration and memory, boosting our metabolism to increase fat burning, and to lower the risk of Alzheimer's and Parkinson's disease. So far, so good.

But then the alarm bells start tinkling. In a study from the *Journal of Toxicology*, researchers tested 30 teas and found that all had high amounts of lead – which can cause kidney and reproductive problems.

Around 70% of teas brewed for three minutes contained potentially unsafe levels.

It gets worse. 20% of strongly brewed teas produce high aluminum and cadmium counts, and teas with added citric acid, like lemon teabags, raised these figures by 50%.

The University of Derby conducted a study of 38 supermarket black tea brands, and found they were particularly high in fluoride.

This was even more elevated in 'economy' or instant tea, but most infused teas create this concern.

Combined with the fluoride found in drinking water and toothpaste, it means that avid tea drinkers are overdosing – too much fluoride causes bone decay, muscle problems and arthritic pain.

A 47-year-old woman developed brittle bones and lost all of her teeth after drinking too much tea, according to a report in the *New England Journal of Medicine*.

What was too much tea? In her case, using 150 teabags a day, to create 12

Less fervent tea lovers would find it safest to stop at 6–8 cups a day, using one teabag per cup.

Clearly, tea drinking has its advantages and drawbacks. But recently, scientists unearthed an unexpected new benefit.

They found that simply drinking tea can reduce stress levels by up to a quarter.

In their experiment, subjects were placed in a troubling scenario, and responded with a 25 per cent increase in anxiety.

However, this was not the case when the volunteers received a nice cup of tea immediately after the stress-inducing test.

Thankfully, it appears that a bit of tea drinking is perfectly safe and pleasant – but please don't use 100 teabags a day to make the tea extra strong.

Your teeth and bones won't thank you.

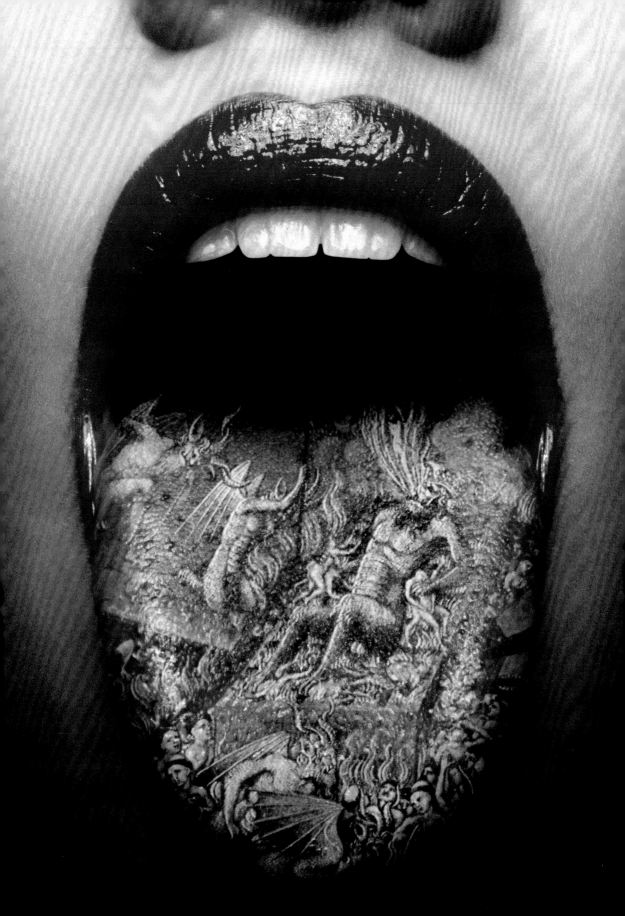

Tattoo you.

It used to be mainly, and manly, sailors who were seen with tattoos, usually a heart intertwined with a lover's name.

In fact, tats have been around since Neolithic times, but have never enjoyed the popularity that they do today; nowadays the most sought after tattoo artists enjoy a celebrity-like status.

So remarkable are some tattoos that institutions, including the National Museum of Australia, have approached the human canvases, asking if they would consider donating their skin once they pass away.

Surprisingly, The Wellcome Collection in London has the world's largest collection of tattooed skin, with over 300 prime examples.

Irish performance artist Sandra Ann Vita Minchin plans to auction off the tattoo on her back, apparently far superior to the one featured on the Girl with the Dragon Tattoo. Her piece is a recreation of a 17th Century Dutch masterpiece, and will be going to the highest bidder after she dies.

In the past, preserved tattoos were saved for criminologists, particularly by the Russian KGB, to decipher their meaning and create a 'taxonomy of symbols to understand the criminal psychology'.

Russian convicts like to illustrate their autobiographies, however vicious, onto their bodies, alongside their rank in the criminal brotherhood.

Tattooing in prison is itself a challenge. Without traditional ink, inmates are forced to be experimental, and find that a concoction of melted rubber from tyres or shoe soles, mixed with blood and urine, gives the best results.

Prison tattoo artists utilise a homemade electric kit with a razor, ballpoint pen and sharpened guitar string.

Generally these days, tattoos are focused more on being splendid works of art.

But for all the magnificent tattoos out there, there are many times that number of very bad ones. According to a survey, one million Britons have been tattooed during, or after a late night drinking session.

As a result, four out of ten people with tattoos regret having them done, leading to a vast increase in business for laser removal clinics.

The most widely removed tattoos are those of an ex's name – known as 'the kiss of death to any relationship' in the industry.

However they are still growing in popularity, with one in five Britons having a tattoo, according to research by the British Association of Dermatologists – and up to one third of under 25s.

The most die-hard fans are even tattooing the whites of their eyeballs, to terrifying effect.

In fact, the taboo surrounding skin art has dissipated to the point that they are firmly mainstream, no longer resigned to sub-culture. Even Samantha Cameron has a little dolphin tattooed on her ankle.

In the UK, the growth of tattoo parlours has outstripped that of any other High Street staples, like betting shops.

However, despite their appeal to so many people, employers haven't quite managed to keep up.

In the workplace there is still a stigma attached to visible inkings, and tattooed employees are linked with words such as 'untidy', 'repugnant' and 'unsavoury' in research conducted by major companies.

Guidelines which restrict tattoos are still commonplace; if you have any on your face, hands or above the collar line, you will be unable to join the Metropolitan Police.

Airlines also frequently place tattoo restrictions on their cabin crew.

Around the world, tattooed people are generally not protected by employment laws covering discrimination.

But nonetheless, should you still wish to join the ranks of the illustrated people, *Inked* magazine predicts some of the tattoo trends for 2017.

Go for minimalist, cubist or a single line tattoo, if you're hip enough.

What's more brutal, boxing or ballet?

If ballerinas were animals, ballet would be banned as being savagely cruel.

The agony dancers are expected to perform through is the very definition of exquisite torture, mercilessly poised on the tips of their toes for hours each day.

But unlike footballers, they don't get rested if they feet are screaming – if they can't perform, they lose their role to another eager dancer ready to pirouette in.

Extreme sports that are wildly hazardous have grown in popularity in recent years, the danger itself clearly being the captivating appeal.

ase jumping, freediving, hang gliding, snowboarding, ice climbing – the list of perilous activities is lengthy, unlike the lives of many of the participants.

As humans we seem driven to push our limits, but while we might not all be able to scale ice mountains with picks, there are still manifold dangers in what are considered 'safer' sports.

In ice hockey, broken ankles, arms, shoulders and knees, bleeding eye sockets, and skull fractures are amongst the routine injuries to players.

The damage sustained by American football players has ended many promising careers. Any bone that you can think of will be broken by someone each season, with one poor linebacker having his middle finger ripped clean off inside his glove.

Bizarrely, angling kills more people in the UK each year than any other sport; though it is hardly considered an Extreme sport, people fishing can regularly end up drowning.

Rugby supporters proudly boast their game is like American Football, but without all the girly padding.

Not surprisingly, dislocated ankles, concussions, black-outs, shattered bones and torn ligaments are all commonplace.

Of course, the main cause of death in sport is brain trauma.

The *British Journal of Sports Medicine* studied injuries to racing drivers, and concluded that the most demanding aspect of the sport is the high incidence of concussion, sometimes proving lethal or incapacitating.

But nothing worries physicians and critics like boxing.

Debate has been endless about whether the sport should be abolished. Since 1884 when the Marquis of Queensberry rules were introduced, approximately 500 fighters have died in the ring.

A report in the *British Medical Journal* quantified the serious injury rate to boxers during competition at 828 per 1,000.

However, human curiosity seems to trump concerns about safety. Californian teenagers introduced the world to Butt-boarding, lying flat down on their skateboards to hurtle down steep open roads.

In Britain David Kirke founded the 'Dangerous Sports Club' and has even adapted the trebuchet, a medieval device for throwing rocks, to catapult enthusiasts from zero to 55 feet into the air in 1.9 seconds, hopefully to land in a net.

If you don't feel like hurling yourself out of an airplane, or running head first at your opponents, then underwater sports provide more buoyancy.

They do however come with their own set of hazards.

Master of the seas Jacques Cousteau invented the 'Aqua-Lung' in 1943, effectively founding the British Sub-Aqua Club.

With over 35,000 members, a tally of their fatalities makes terrible reading – 197 deaths in just the last 12 years.

If you think you might be better off keeping fit by jogging around the park a few times, remember that long-distance running has been known to end in more than sore feet.

In the US between 1975 and 2004, 26 people collapsed and died while attempting to run a marathon – about the same number of fatalities as in sky-diving.

But almost certainly, diehard extreme sports fanatics couldn't handle having their feet tortured for a couple of hours, balancing on their toes 'en pointe'.

Do you find it easy to drift off?

Can you sleep through anything – crashing thunderstorms, the TV blaring, the wail of police car sirens past your bedroom?

Some people can, while others are awakened by the slightest tinkle – a teaspoon being dropped in the kitchen a floor below.

Worse than being too easily woken is having the burden that many of us have to cope with – persistent insomnia. Sufferers sleep fitfully on a good night, and toss and turn for seemingly endless hours on a poor night.

Just like breathing, sleeping is a fundamental requirement for survival. This is often overlooked as people push the limits further, trying to squeeze more hours out of the day. But in truth, you would probably survive three times as long without food as you could without sleep.

S leep deprivation is not only deeply unpleasant, it has profound effects on the body. Your brain cells start to shrink, and your hormones start to play-up, setting off a chain reaction.

Melatonin, which inhibits the proliferation of cancer cells, stops being produced. The fat regulating hormone leptin is inhibited, and your hunger hormone ghrelin increases. You are left feeling hungry even if you've already eaten, often leading to weight gain. Interrupted or impaired sleep also increases your risk of heart disease, and further hormone fluctuations increase stress levels. It contributes to premature ageing by interfering with growth hormone production, normally released by your pituitary gland during deep sleep, or after exercise.

Remarkably, the two great nuclear disasters that have occurred in recent decades have both been linked to a lack of sleep.

In both the cases of Chernobyl and the Three Mile Island calamities, engineers had been working for 13 hours or more. At Three Mile Island the incident was specifically attributed to 'human error due to sleep deprivation'.

The Challenger spacecraft explosion was another major catastrophe believed to be the result of lack of sleep. The team involved in the launch had slept for only two hours before reporting back to work at 1am.

Challenger exploded after take-off on January 1986 killing all seven on board. The Presidential Commission on the accident noted: "The willingness of NASA employees in general to work excessive hours, while admirable, raises serious questions if it jeopardises job performance, particularly when critical management decisions are at stake."

In 1989 the crew of the giant commercial vessel Exxon Valdez had completed a 22 hour shift loading oil – and the ship's third mate fell asleep at the helm, only for the tanker to run aground.

In the worst environmental disaster the world had known it spilled vast floods of pollution, impacting 1,300 miles of coastland and 11,000sq miles of sea.

Signs to look out for from a lack of enough sleep are:

Hunger – if you're hungrier than usual, not because you've been to the gym or skipped a meal, chances are that you need some shut-eye.

Feeling more emotional than usual – finding yourself getting upset or teary over little things signals that you are probably in need of a nap, not unlike a small child. Worse, sleep deprived brains react far more deeply to negative and disturbing thoughts.

Being forgetful or unfocused – too little sleep causes of a lack of attention, confusion, forgetfulness and difficulty in comprehension.

You are also clumsier than usual, you drive more erratically.
And you just can't shake that cold that's been clinging to you for a week. If you're desperate for a perfect night, you could try taking your mattress to the Serpentine lido…. and gently drift off.

The worst job in the world?

Possibly, there are more horrible jobs than being an armpit sniffer, testing products in a deodorant factory.

Hopefully your job is more congenial, even if you do dislike it some days. But like all of us, on some days you are the dog, and on some days you are the lamppost.

When you find your boss infuriating, when work seems a tiresome intrusion on your life, when each dull day follows on remorselessly from the dullness of the day before – remember the cruel fact that many, many people are depressed by their job.

Of course, there are countless self-help manuals to help people cope with this trauma. If you are looking for a really soul-crushing job, you could try reading them all.

What is it that keeps people chained to a job that makes them feel under-appreciated or not appreciated at all, nothing more than a resource?

There's the obvious – a steady income, the uncertainty of finding a better job, the baleful hope that things will get better if you get promoted.

But more usually, it's because you have already invested so much time, effort and energy in your current employment, it makes walking away difficult.

It's important to know what you really want. The biggest mistake job seekers make is being unable to articulate, even to themselves, the work that they genuinely crave.

Ideally, see if you can turn what you really enjoy doing into a job that makes you money – that way, work doesn't feel like work.

This isn't an unrealistic option – it's not just the successful bloggers and vloggers that make a living out of their interests.

The key is to cultivate a career that you enjoy, that you're good at, that people will pay you handsomely for.

For example, if you are a whizz at computer games, counting down the hours until you can return to your console, why not consider a career change to become a programmer?

There are numerous institutions popping up across the city that offer part time courses, and with these new skills you could build your own online game, or come up with a breakthrough new app, or at the very least become an in-house IT guru at an exciting new tech start-up.

If your favourite part of the day is heading to the pub after work, then why not consider a change in vocation and become a wine expert, always in demand in the catering world, or even a brewer of fine beer?

Craft beer has seen a surge in popularity recently, and interesting new brews are always welcome.

Two textile students, Aurelie Popper and Jade Harwood started a successful business around their love of knitting.

The duo were unable to find the patterns for items they actually wanted to make and wear, and so Wool and the Gang was born.

You can buy their knitted garments ready-made, or opt for them to send you the materials and instructions, for around half the price.

Alice Barrow and Tom Green began making luxury candles for fun, mixing the different colours, scents and waxes at home, and then selling them for £35 on a market stall in their spare time. The demand grew to the point where they outsourced large scale production and soon landed a contract to supply a major retailer. Their brand Wick and Tallow is now a thriving business.

Always remember, as you struggle all hours to build your idea into a money-spinner, it has to be more uplifting than sniffing armpits all day.

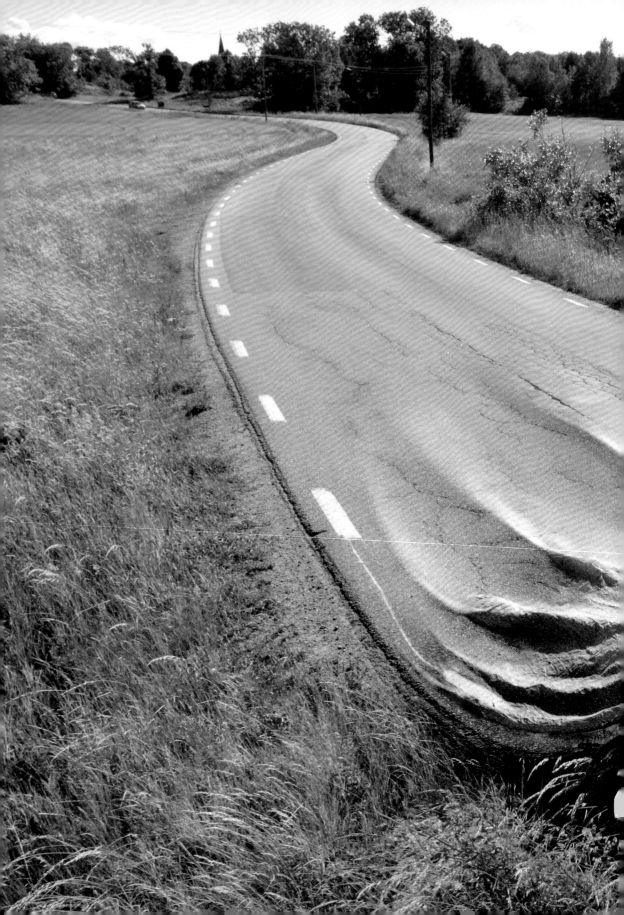

The road less travelled.

Do you ever dream of a driving holiday, exploring America or Europe in the comfort of your car?

If you like to make it easy on yourself, without too many maps or sat navs to consult, there are a number of recommendations.

How about just following the Pan American Highway? It's the world's longest, at 16,000 miles – and it carries you from Canada, through the United States, down to Mexico, Costa Rica and Peru.

How hard could it be to get lost on one giant motorway? At worst you may get a little bored of endless unchanging road, dotted by the same kind of food restaurants and petrol stations every dozen miles.

If you want a little variety, as you head through Texas you could sample the Katy Freeway, the widest highway in the world with 26 lanes to help ease you through the state.

Perhaps you own a Lamborghini, a Porsche Boxster, or a similar supercar? You must ache to unleash its full horsepower on some of Germany's autobahns – the ones with no speed limit. Cars are routinely clocked at well over 150 mph, gliding effortlessly past the slowcoaches in the middle lane travelling at a dull 120 mph.

If you seek relaxation for your trip, you might look for roads that require none of the effort of having to deal with curves. You would enjoy Highway 10 in Saudi Arabia, 162 miles that's flat, and dead straight.

Equally easy to navigate is the 90 miles of absolutely straight tarmac on the Australian Eyre Highway. The C017 in Colorado offers 48 miles without a turn of the steering wheel, on the ruler-straight highway running throughout the San Luis Valley.

But you may prefer a road that is more testing of your driving skills, and be drawn to Fairy Meadows in Pakistan. The name is somewhat misleading as there are no meadows near this 16 miles of deadly highway next to the giant Nanga Parbat mountains. Much of the unpaved, unlit road ascends with no barriers on either side – drivers frequently plummet off, particularly during snowfall and small avalanches.

After such a daunting journey, you might welcome the calm of the world's longest tunnel, running 6,000 feet high through Norway's mountains, for 15 miles. Norway is also home to Trollstigen, the Troll Ladder, with the bends and gradient on this mountain pass being exceptionally tight and steep.

It's hard to decide whether the nightmarishly endless tunnel is best tackled before or after the Troll has sapped your spirit of adventure.

In any event, if you prefer bridges to tunnels then head for the Millau Viaduct spanning the river Tarn in France. It stands 1,125 feet high, taller than the Eiffel tower, and comfortably the highest bridge in the world.

It is so high in fact, the most daunting engineering challenge the bridge presented was to build the viaduct so it was able to withstand the 95 mile winds regularly battering it.

Of course, most of us prefer a picturesque road trip to one where we simply settle into endless miles of superhighway. There are many contenders for the world's most beautiful drive, but aficionados declare that the Dalmatian Coast Road in Croatia is hard to beat.

With views of the Adriatic Sea and islands to one side, and stunning mountains, lovely fishing villages and classical architecture on the other, it is apparently Europe's best-kept secret.

But if you prefer a vista of miles of endless sand, there is always that Highway 10 in Saudi Arabia, with only the odd camel to blight the view.

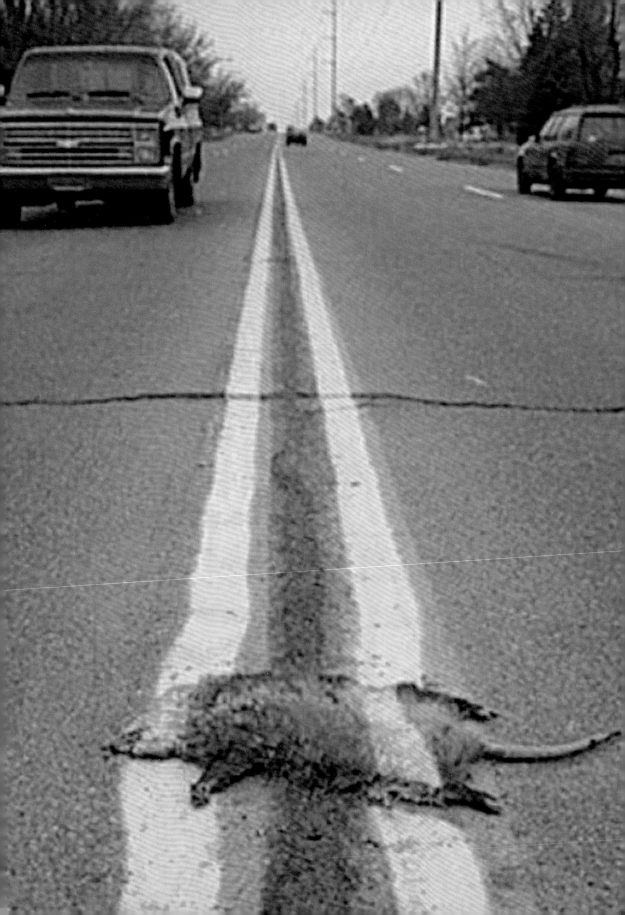